Fragonard:
100 Paintings and Drawings

By Maria Tsaneva

First Edition

Fragonard: 100 Paintings and Drawings

Copyright © 2015 by Maria Tsaneva

Foreword

Jean-Honoré Fragonard (1732 – 1806) was a French painter and printmaker whose late Rococo manner was distinguished by remarkable facility, exuberance, and hedonism. One of the most prolific artists active in the last decades of the Ancien Régime, Fragonard produced more than 550 paintings (not counting drawings and etchings), of which only five are dated. Among his most popular works are genre paintings conveying an atmosphere of intimacy and veiled erotic. Fragonard has been bracketed with Watteau as one of the two great poetic painters of the unpoetical 18th century in France. A prodigiously active artist, he produced more than 550 paintings, several thousand drawings, and 35 etchings. His style, based primarily on that of Rubens, was rapid, vigorous, and fluent, never tight or fussy like that of so many of his contemporaries. Although the greater part of his active life was passed during the Neoclassical period, he continued to paint in a Rococo idiom until shortly before the French Revolution. Only five paintings by Fragonard are dated, but the chronology of the rest can be fairly accurately established from other sources such as engravings, documents, etc.

Fragonard was born at Grasse, Alpes-Maritimes, the son of François Fragonard and Françoise Petit. He was articled to a Paris notary when his father's circumstances became strained through unsuccessful speculations, but showed such talent and inclination for art that he was taken at the age of eighteen to François Boucher, who, recognizing the youth's rare gifts but disinclined to waste his time with one so inexperienced, sent him to Chardin's atelier. Fragonard studied for six months under the great luminist, then returned more fully equipped to Boucher, whose style he soon acquired so completely that the master entrusted him with the execution of replicas of his paintings.

Though not yet a pupil of the Academy, Fragonard gained the Prix de Rome in 1752 with a painting of "Jeroboam Sacrificing to the Golden Calf".While at Rome, Fragonard contracted a friendship with a fellow painter, Hubert Robert. In 1760, they toured Italy together, executing numerous sketches of local scenery. It was in these romantic gardens, with their fountains, grottos, temples and terraces, that Fragonard conceived the dreams which he was subsequently to render in his art. He also learned to admire the masters of the Dutch and Flemish schools, imitating their loose and vigorous brushstrokes. Added to this influence was the deep impression made upon his mind by the florid sumptuousness of Giovanni Battista Tiepolo, whose works he had an opportunity to study in Venice before he returned to Paris in 1761.

In 1765 his "Coresus et Callirhoe" secured his admission to the Academy. It was made the subject of a pompous eulogy by Diderot, and was bought by the king, who had it reproduced at the Gobelins factory. Hitherto Fragonard had hesitated between religious, classic and other subjects; but now the demand of the wealthy art patrons of Louis XV's pleasure-loving and licentious court turned him definitely towards those scenes of love and voluptuousness with which his name will ever be associated, and which are only made acceptable by the tender beauty of his color and the virtuosity of his facile brushwork and his decorations for the apartments of Mme du Barry and the dancer Madeleine Guimard.

A lukewarm response to these series of ambitious works induced Fragonard to abandon Rococo and to experiment with Neoclassicism. He married Marie-Anne Gérard, herself a painter of miniatures, and had a daughter, Rosalie, who became one of his favourite models. In October 1773, he again went to Italy with Pierre-Jacques Onézyme Bergeret de Grancourt and his son. In September 1774, he returned through Vienna, Prague, Dresden, Frankfurt and Strasbourg.

Back in Paris Marguerite Gérard, his wife's 14-year-old sister, became his pupil and assistant in 1778. In 1780, he had a son, Alexandre, who became a talented painter and sculptor. The French Revolution deprived Fragonard of his private patrons: they were either guillotined or exiled. The neglected painter deemed it prudent to leave Paris in 1790 and found shelter in the house of his cousin Maubert at Grasse, which he decorated with the series of decorative panels known as the Les progrès de l'amour dans le cœur d'une jeune fille.

Jean-Honoré Fragonard returned to Paris early in the nineteenth century, where he died in 1806, almost completely forgotten.

Paintings and Drawings

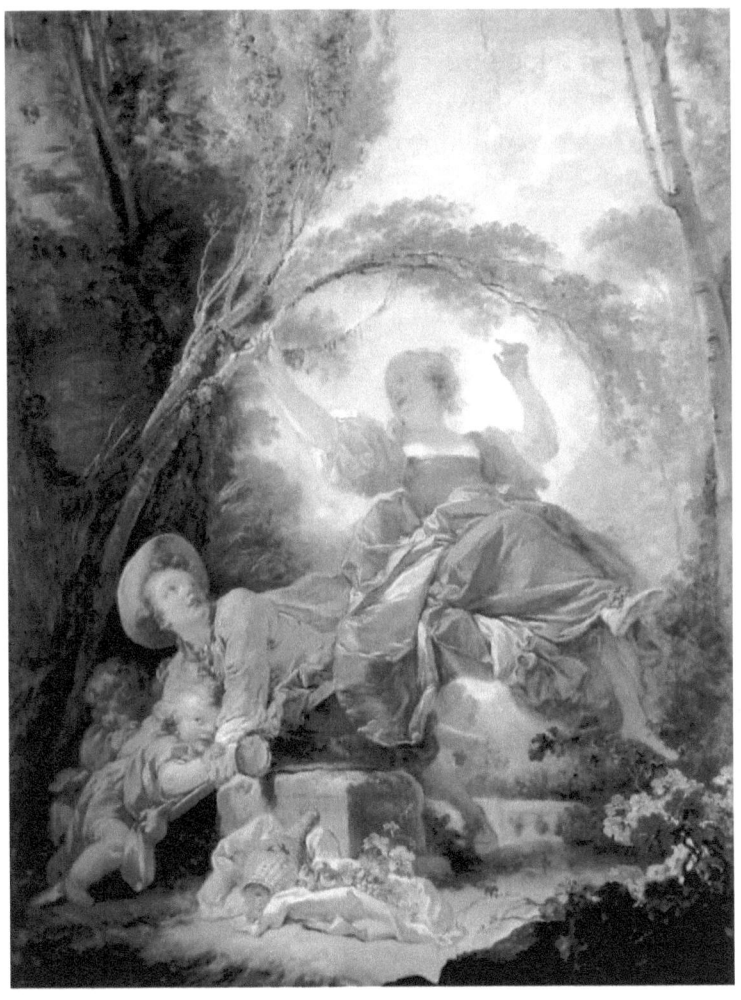

The Swing, 1750, Oil on canvas

This painting was executed during or just after the period in which Fragonard was a pupil of Boucher, whose influence is apparent both in its subject matter and technique. Years later, Fragonard would paint another work with the same title but of a very different character, in which the subject's eroticism is made obvious. The painting (now in the Wallace Collection, London) has become one of his most famous.

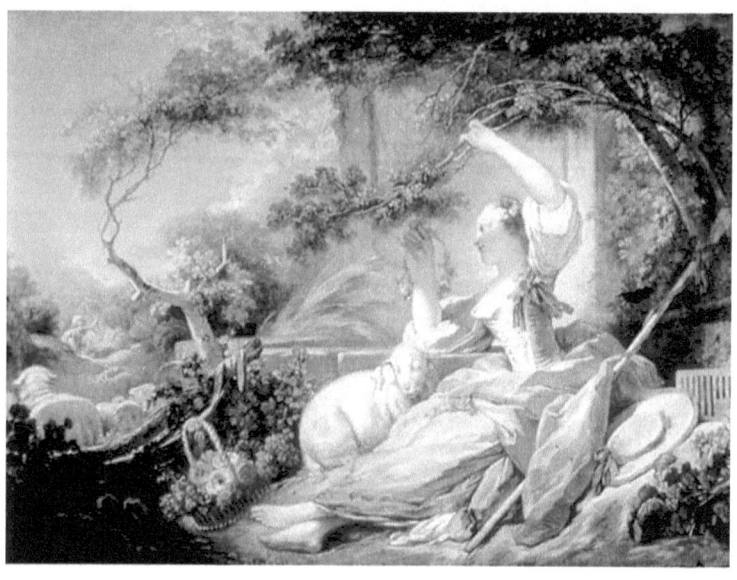

The Shepherdess, c.1750-1752, Oil on canvas

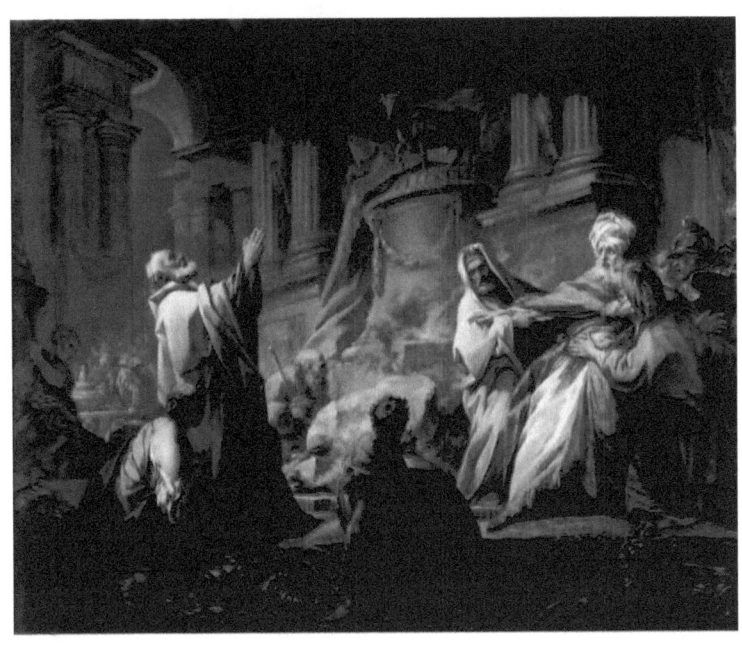

Jeroboam Offering Sacrifice for the Idol, 1752, Oil on canvas, 115 x 145 cm

According to the Books of Kings, Jeroboam was the first king of the break-away ten tribes or Northern Kingdom of Israel, over whom he reigned twenty-two years. Fragonard's painting depicts Jeroboam offering sacrifice for the idol of the Golden Calf. While he was engaged in offering incense, a prophet from Judah appeared before him with a warning message from the Lord. Attempting to arrest the prophet for his bold words of defiance, his raised hand was "dried up," and the altar before which he stood was rent asunder. With this painting Fragonard won the Grand Prix de l'Academie Royale in 1752.

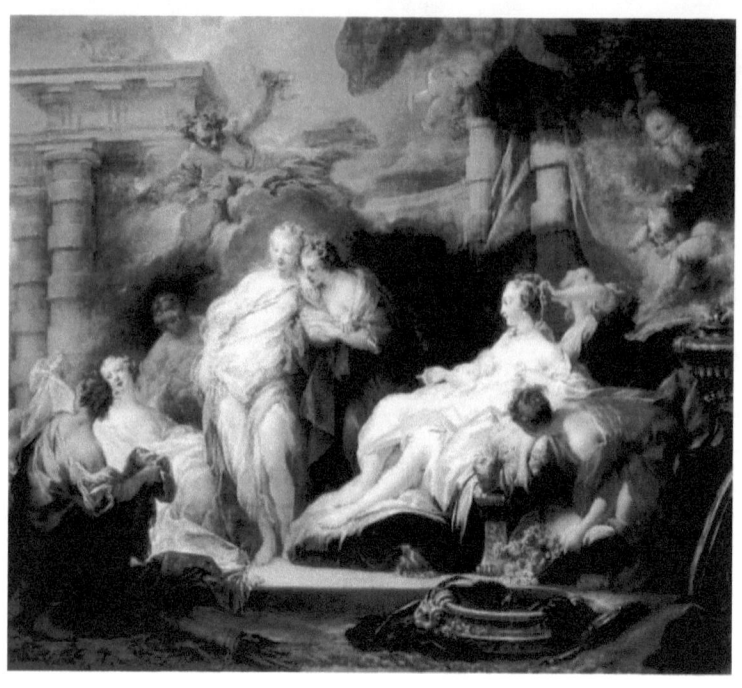

Psyche showing her sisters her gifts from Cupid, 1753,
Oil on canvas

A prize-winning pupil of Francois Boucher, Fragonard in this youthful picture, painted at the Ecole des Elnves Proteges in Paris, seems a perfect exponent of the taste of Boucher's patrons King Louis XV and his mistress the Marquise de Pompadour. However, after an unsuccessful final bid for institutional recognition at the Paris Salon exhibition of 1767, Fragonard virtually disappeared from official artistic life under the monarchy, working almost entirely for private patrons, many of them his friends. He was thus able to give free rein to a more individualistic celebration of nature, instinct and impulse.

Whether in oils, gouache, pastels, in engravings and etchings, or in his many drawings in chalk, pen or wash, he came to efface the distinctions between sketch and finished work, and even between the boundaries of the genres. We cannot always tell, for example, whether any one of his many pictures of single figures is a portrait in fancy dress, or imaginary.
On his two visits to Italy, the first to the French Academy in Rome (1756-61), and the second over a decade later as the guest of a patron, Fragonard was drawn to the landscape and to contemporary and near-contemporary Italian artists, notably Tiepolo and Giordano. He was unmoved either by ancient ruins or by Renaissance art. With the collapse of the art market during the French Revolution he retired to his native Grasse in Southern France, but was drawn into politics by his son's teacher, the painter David. His late paintings show him trying to conform, not always successfully, to the Neo-classical austerity of David's 'republican' style.

The subject here is drawn from the allegorical tale of Cupid and Psyche by the Latin poet Apuleius, probably in a French version by La Fontaine. Psyche is showing off her 'storehouses of treasure' to her sisters in the magical castle in which she has been installed by Cupid, god of love. The sisters 'conceived great envy' - personified here by the serpent-haired figure of Eris, goddess of discord, hovering above - and try to wreck her happiness by destroying her faith in her invisible lover. In its handling of paint, and in such details as the chubby flying babies - the putti of ancient art, who here represent the castle's invisible servants - the picture, painted when the artist was barely 21, betrays the influence of Rubens's works at the Luxembourg Palace and also of Watteau.

The composition is derived from a tapestry design for the same subject by Boucher. But the colours, with harmonies of gold and orange beginning to replace Boucher's accords of rose and blue, are already recognisably Fragonard's own. They appear in their purest and most concentrated form in the flowers at the foot of Psyche's throne, the area of the painting most clearly 'in focus'. Definition diminishes towards the edges of the picture, as it might in a convex mirror, and with it the colours tend to lose their identity, to mix and mingle, framing the main figures in shades of grey or darkened tones, presaging the disasters to come.

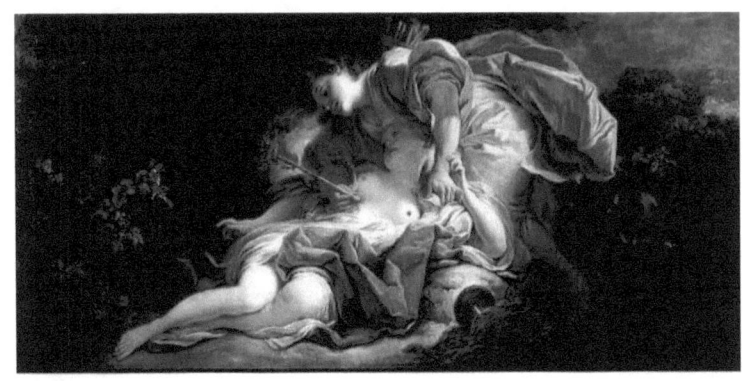

Cephalus and Procris, 1755, Oil on canvas

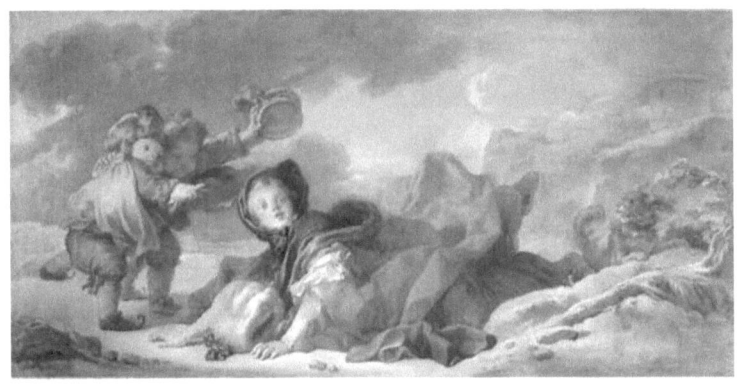

Winter, 1755, Oil on canvas

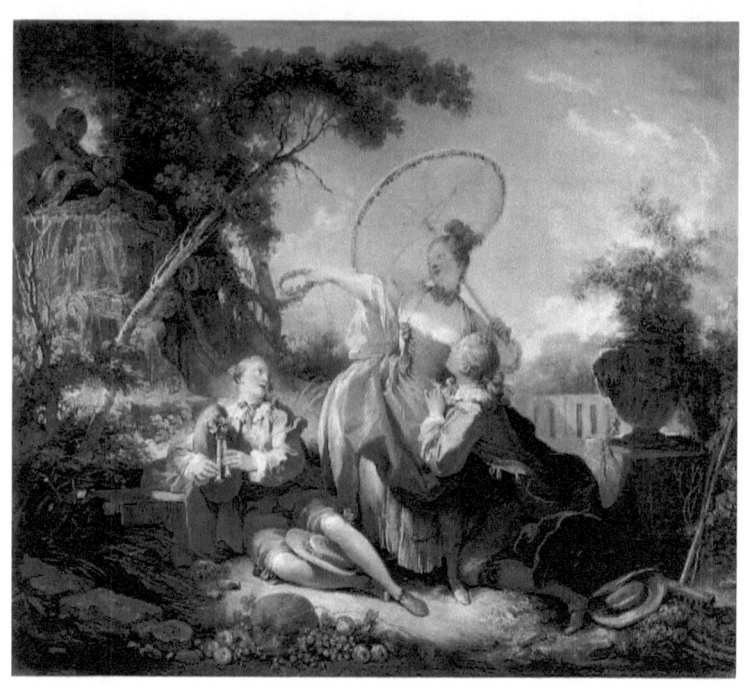

The Musical Contest, c.1754-1755, Oil on canvas

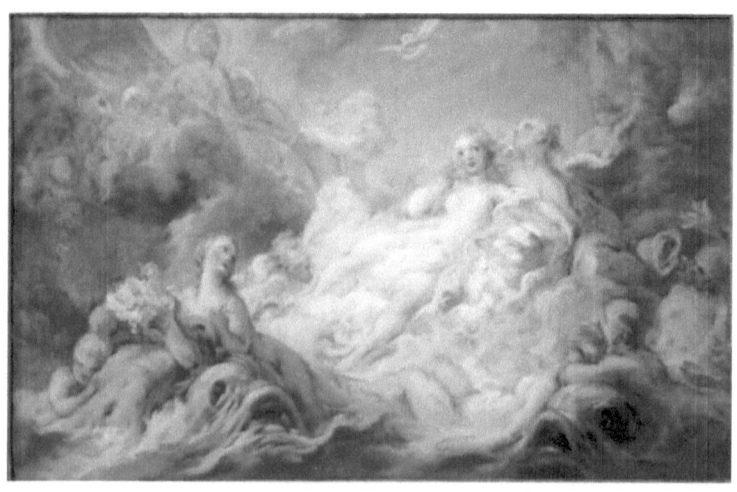

The Birth of Venus, 1753-1755, Oil on canvas

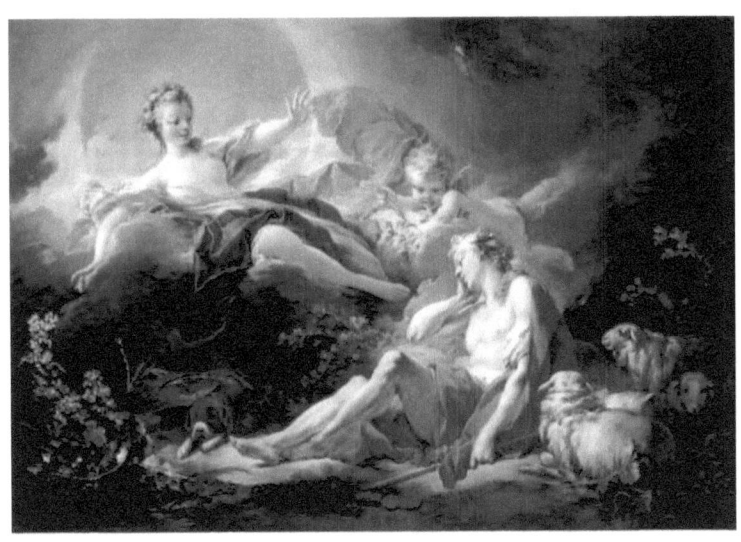

Diana and Endymion, 1753-56, Oil on canvas, 95 x 137 cm

The subject, Diana and Endymion, was a popular one. The story: Endymion, sent to sleep for ever by the command of Jupiter, in return for being granted perpetual youth, was visited nightly by the goddess Diana. The beautiful youth, Endymion, who fell into an eternal sleep, has captured the imagination of poets and artists as a symbol of the timelessness of beauty that is 'a joy forever'.

This early masterpiece by Fragonard demonstrates his brilliant command - even at the beginning of his career - of the Rococo pictorial idiom that was in ascendancy in the 1750s and that he absorbed through his close relationship with Fran3ois Boucher. With its pendant Aurora (private collection) Diana and Endymion was intended as interior decorations, undoubtedly meant to be installed into the paneling of overdoors.

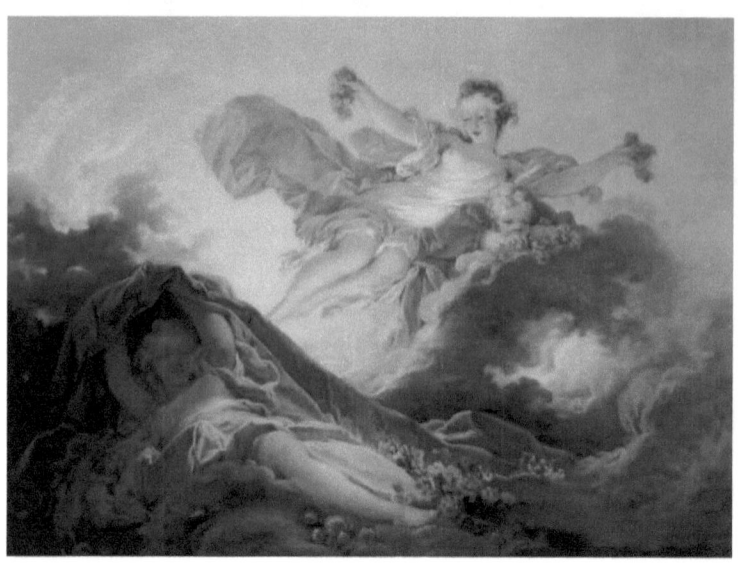

Goddess Aurora Triumphing over Night, 1755-56, Oil on canvas, 95 x 132 cm

This early painting clearly demonstrates that Fragonard had fully absorbed the lessons both of his early masters, Francois Boucher and Carle van Loo, and was beginning to create his own interpretation of the Rococo style. The pendant of this painting, Diana and Endymion, is now at the National Gallery of Art, Washington. The two paintings, both grand in scale and composition, make a perfect pendant pair; they were originally on shaped canvases for placement within a boiserie surrounding. The compositions are flawlessly balanced, with symmetrically positioned sleeping figures arranged across the bottom of each canvas underneath corresponding female deities positioned above.

The Storm, c.1759, Oil on canvas

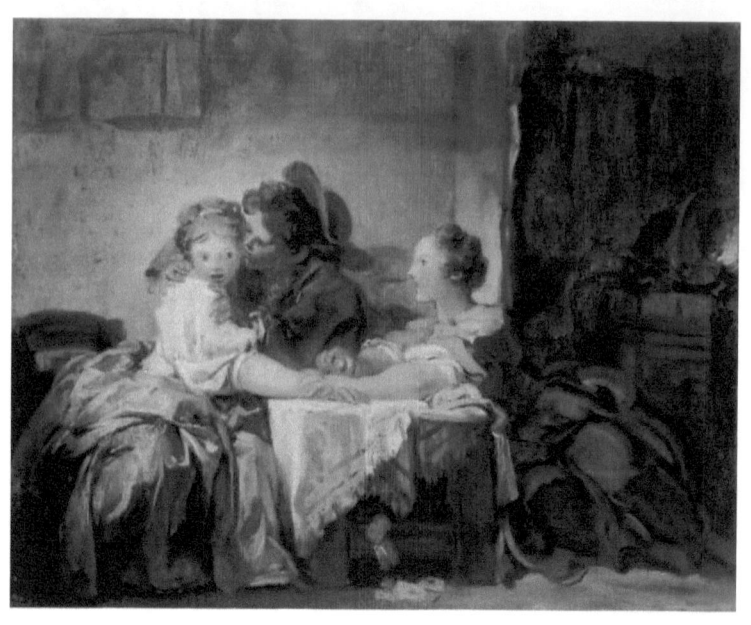

The Prize of a Kiss, 1760, Oil on canvas

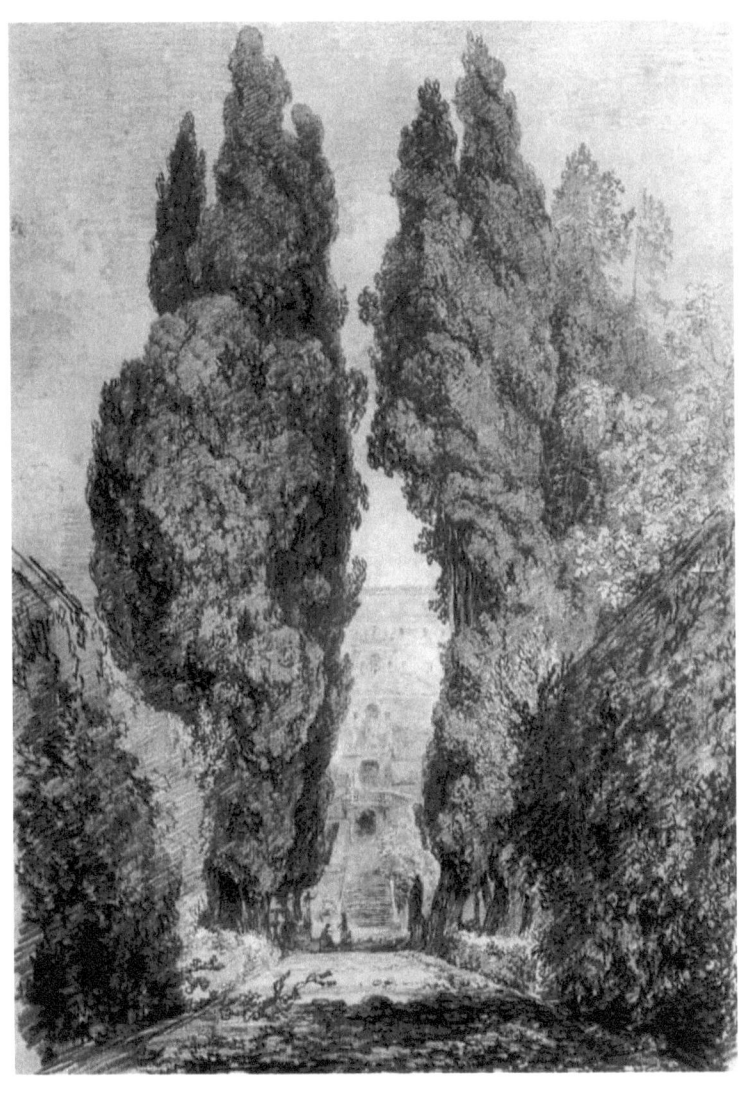

Cypresses in the Garden Avenue of the Villa, c. 1760, Drawing

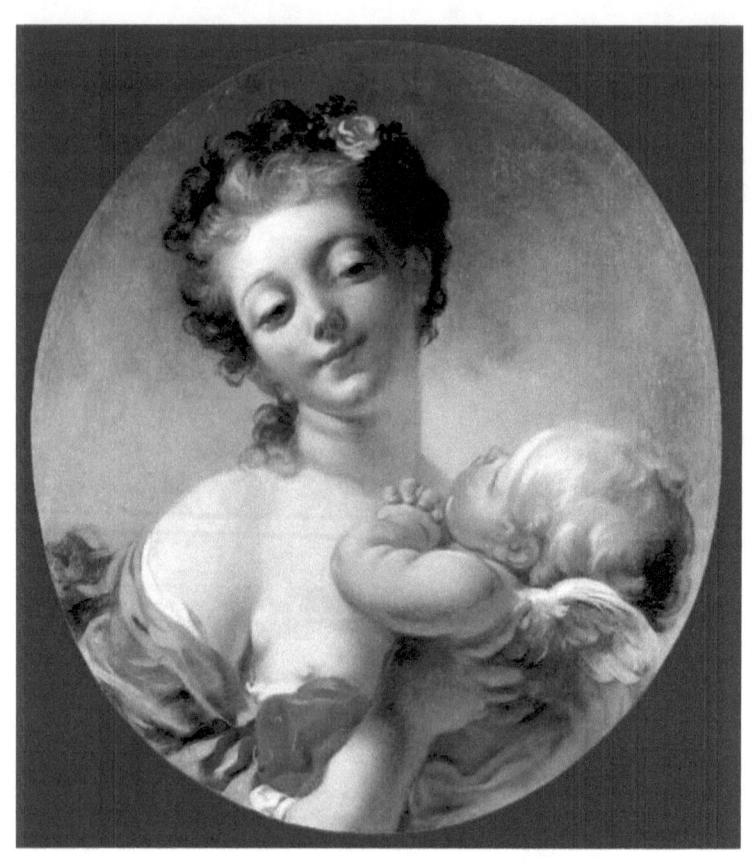

Venus and Cupid, c.1760, Oil on canvas

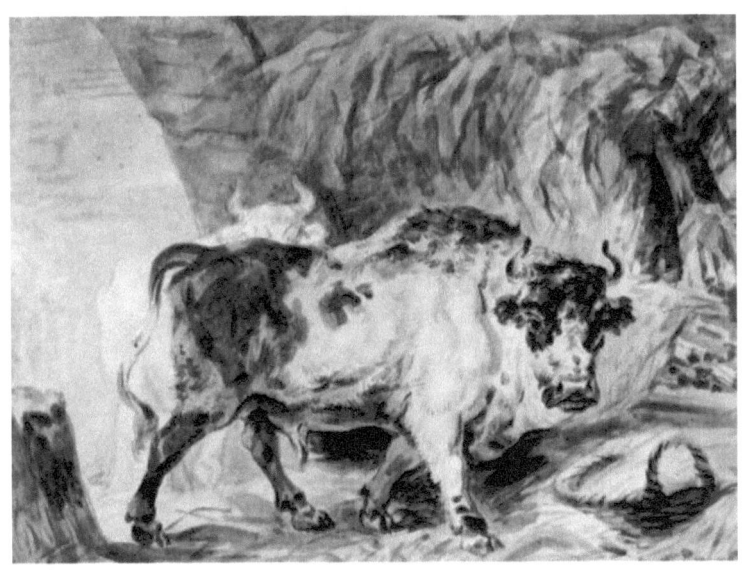

Bull in the stable, 1760, Brush and brown ink on paper

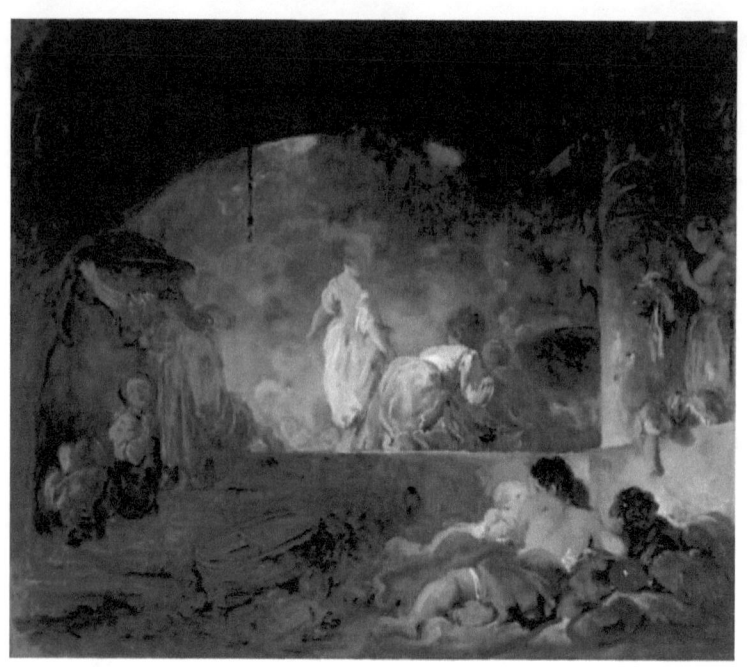

The Laundresses, c.1756-1761, Oil on canvas

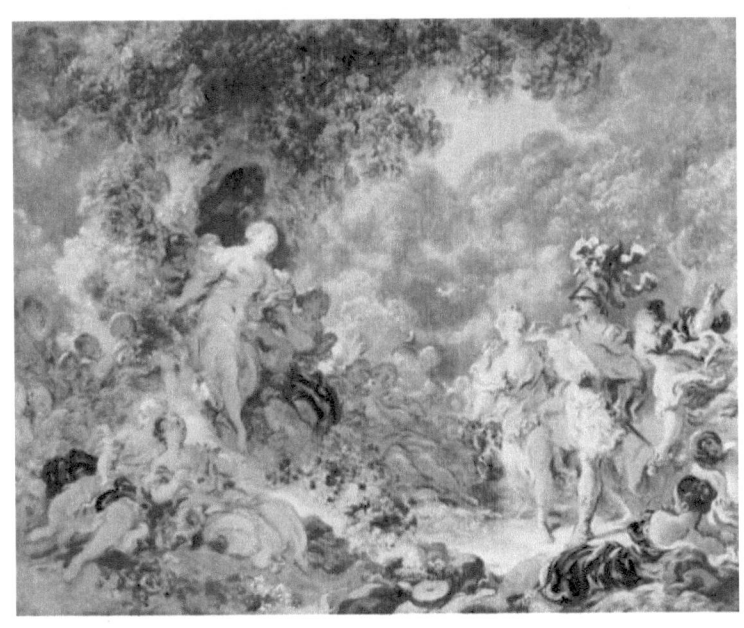

Rinaldo in the garden of the palace of Armida, c.1763,
Oil on canvas

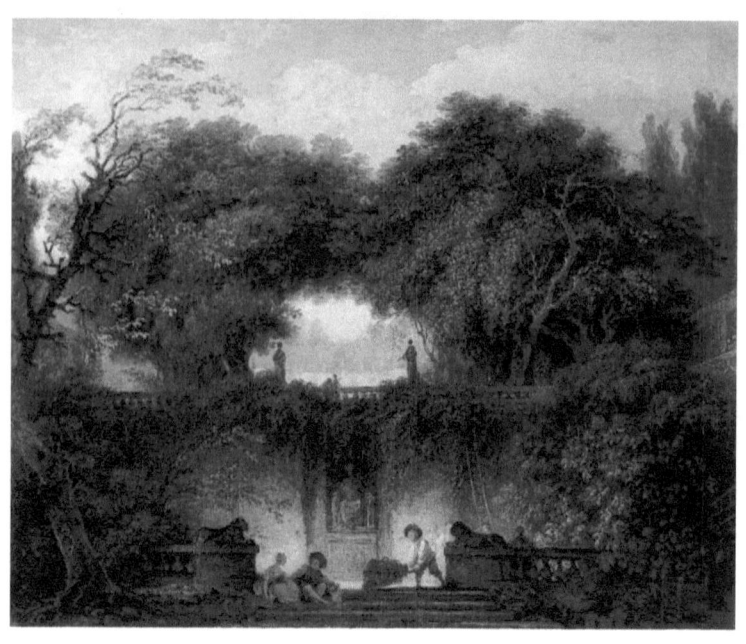

The Small Park, c.1762-1763, Oil on canvas

Fragonard used light and atmosphere to absorb people and objects until one is left with an airy, empty but still vibrating, surface; it is as if a conjuring trick had been played over some painting by Boucher, from which so much 'reality' has been abstracted. For both Fragonard and the Guardi, this is an escape from the discipline represented by Boucher and Tiepolo, but it is given an additional twist by Fragonard's knowledge and admiration of Tiepolo - the wilder genius anyway, but one become wilder and more romantic in Fragonard's interpretations of his compositions. Just as Veronese had provided Tiepolo with material out of which to build his own fantasy, so Tiepolo stimulated Fragonard.

Fragonard is a romantic rococo painter, inspired more perhaps by the picturesque aspects of nature than by people, who are usually dwarfed into insignificance beside the foaming trees which shoot up like great jets in his landscapes. When this Francesco Guardi-like diminution does not take place, Fragonard seems to produce a version of Gian Antonio's style, in which figures become mere arabesques of paint, animated but often faceless, tight balls of energy that shoot about the canvas under the impulse of his brush. In both styles they remain the painter's puppets, and one is always conscious of manipulation. Although capable of doing so, he is really too eager to stop and record natural appearances, actual textures, or facial expressions. This charming parkscape is composed from drawings made in the gardens of the Villa d'Este in Tivoli in 1760.

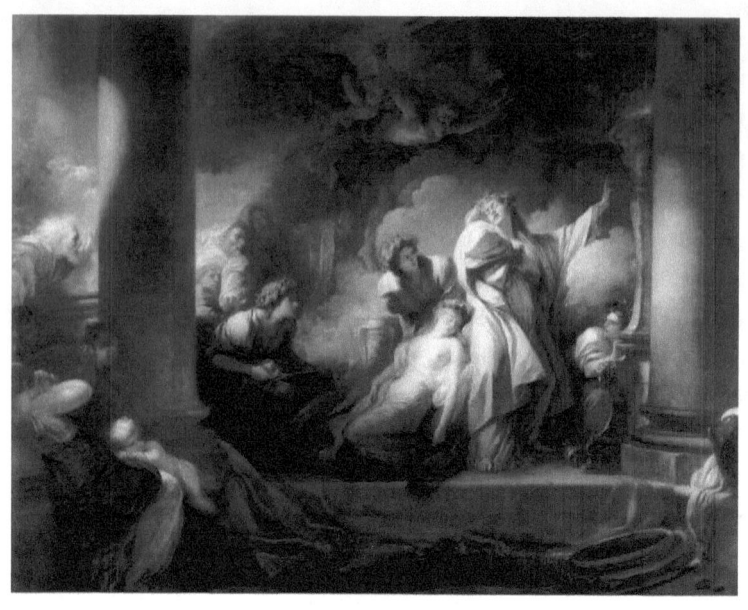

Coresus at Callirhoe, 1765, Oil on canvas

The picture shows a tapestry cartoon for the Gobelin factory. The tapestry was never executed. It was thanks to this painting that Fragonard was accepted by the Academie as a 'history painter'. He was soon to abandon this type of subject-matter and devote himself to the pleasant, often frivolous paintings for which he is famous.

When Fragonard tackled the history picture - a rare occasion - it, like his other paintings, was animated by love. The large Coresus sacrificing himself to save Callirhoe, shown at the Salon of 1765, is Fragonard's effort to combine his own tendencies with academic requirements. It is not surprising that he exhibited there only once afterwards; this sort of machine was replaced by brilliant, witty decorations, positive riots of cupids and bathers, kissing lips and torn clothes, which always express love in action. The Coresus is negative love, sublime self-sacrifice, and in effect useless passion. Fragonard docs his best to excite the composition, sending waves of smoky clouds and excited winged figures to fill the space between the two pillars not occupied by the strangely feminine priest and the swooning heroine - herself almost as if ravished by love. Perhaps hints from Boucher and Tiepolo worked on Fragonard to emulate the high style for which he was not suited. His genius lay in aiming lower, from an academic standpoint, in being more rational and natural - that is, by being wittier, mischievous, and relaxed.

But in 1765 this was not yet apparent, though perhaps suspected. The whole, high, rococo fabric was toppling. For a moment the painter of the Coresus seemed the man who might keep it still upright. The picture itself was thought by Diderot to have attracted attention less by its own merits than by the need in France to find a successor to the established Carle van Loo and the supposedly promising Deshays, both of whom died that year. Boucher's talent had patently declined. Great painters, Diderot wrote in the same context, 'sont aujourd'hui fort rares en Italie', and the only person he could think of comparing with Fragonard was Mengs. At Venice, Gian Antonio Guardi was dead; Tiepolo was self exiled in Spain; Pittoni, last of the generation of talented practitioners still in the city, was to die in 1768.

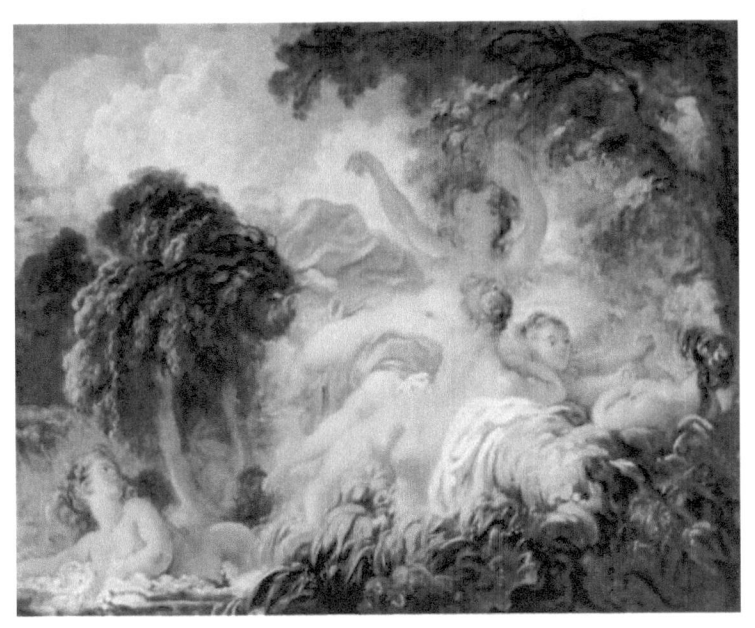

The Bathers, c.1765, Oil on canvas

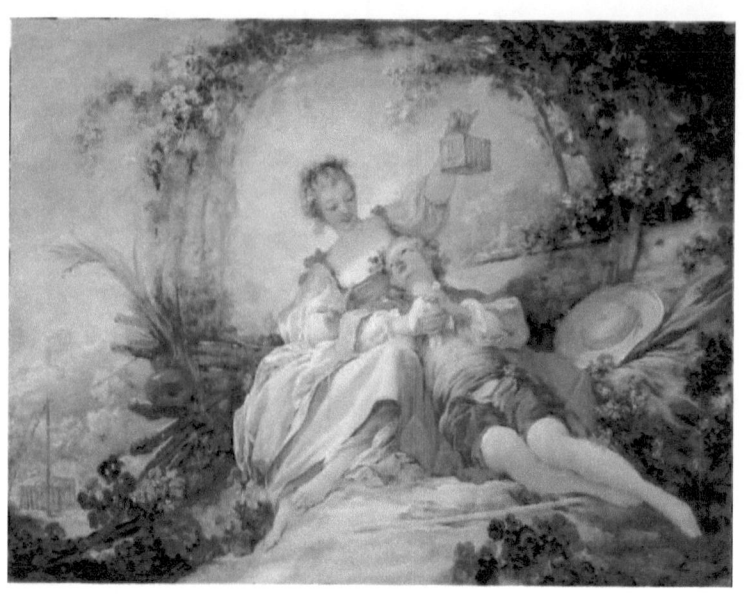

The Happy Lovers, 1760-1765, Oil on canvas

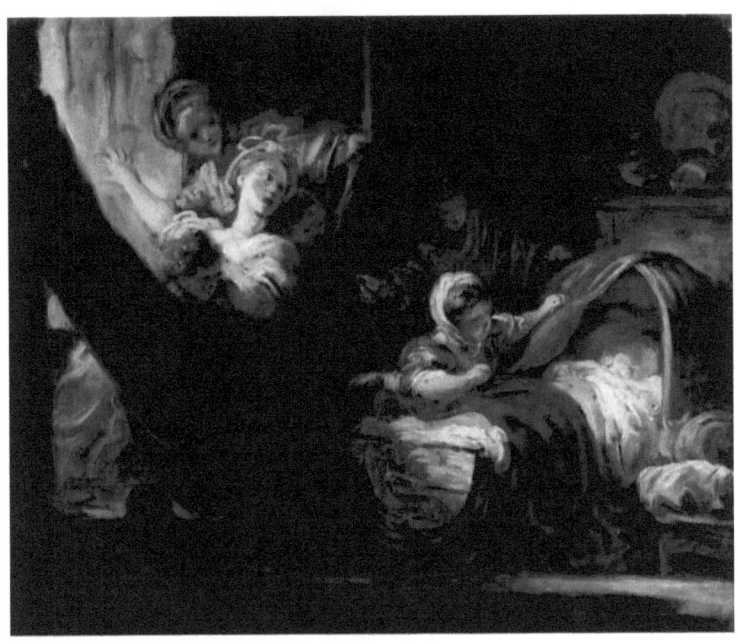

The Cradle, 1761-1765, Oil on canvas

This painting shows the strong influence of Rembrandt, especially that of Rembrandt's Holy Family which in the 18th century was in Paris and Fragonard made a copy of it.

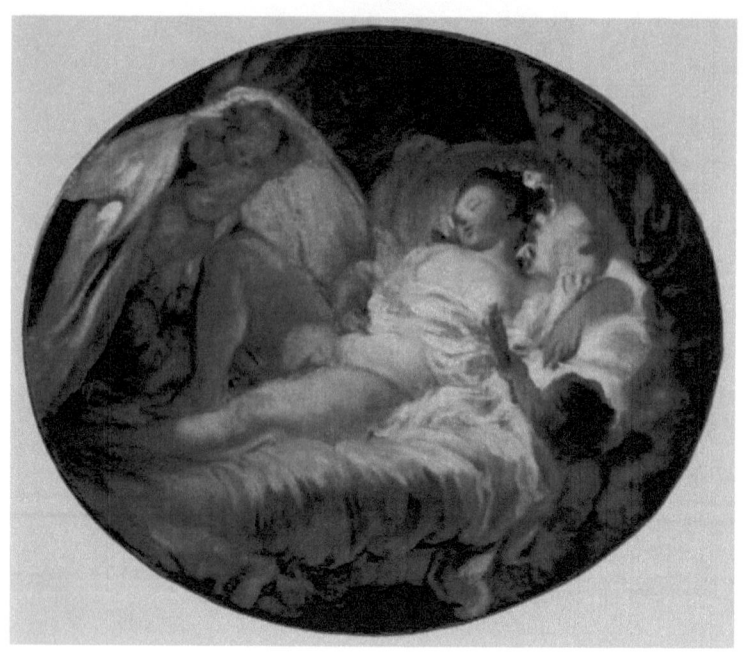

Match to Powderkeg (Le feu aux poudres), 1763-64, Oil on canvas, 37 x 45 cm

Fragonard had begun producing erotica after his first Italian sojourn. His light, casual, yet confident handling can be seen in such works as Le feu aux poudres. They celebrate an adolescent pleasure, a rare ensemble in which the thrill of desire is exalted without the least trace of vulgarity.

The Watering Place, 1763-1765, Oil on canvas

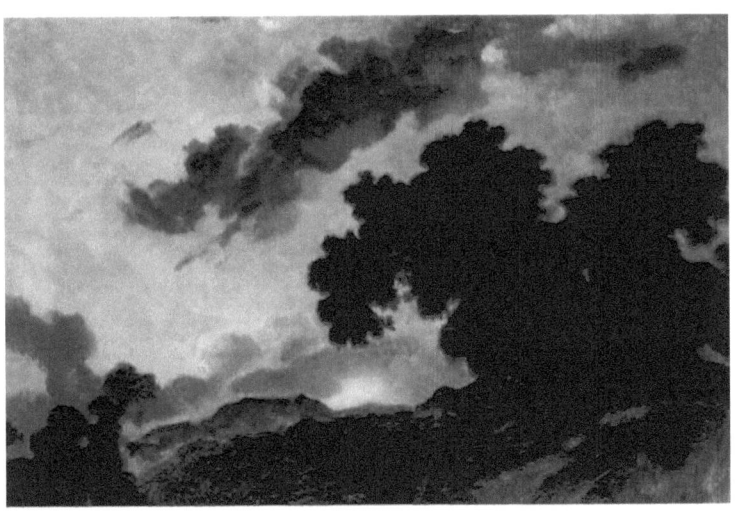

Mountain Landscape at Sunset, c. 1765, Oil on paper, 22 x 33 cm

This small painting on paper is among the few surviving oil sketches by Fragonard that plausibly could have been painted in the open air. It illuminates a little-known aspect of his practice as landscapist.

In the mid-eighteenth century the custom of drawing outdoors was an established part of a young artist's training. Fragonard produced spectacular series of landscape drawings during his early sojourn in Italy from 1756 to 1761, when he was a pensioner at the Academie de France in Rome. He continued to draw from nature throughout his career. Making open-air studies in oils, however, was still relatively unusual during this period.

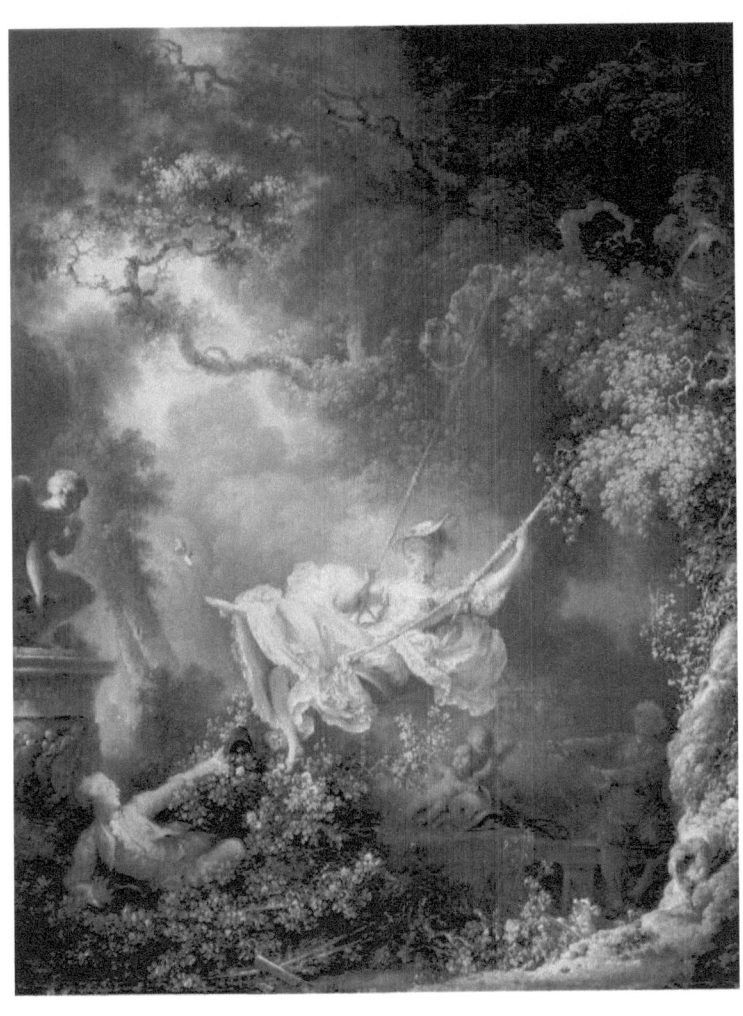

The Swing, 1767, Oil on canvas

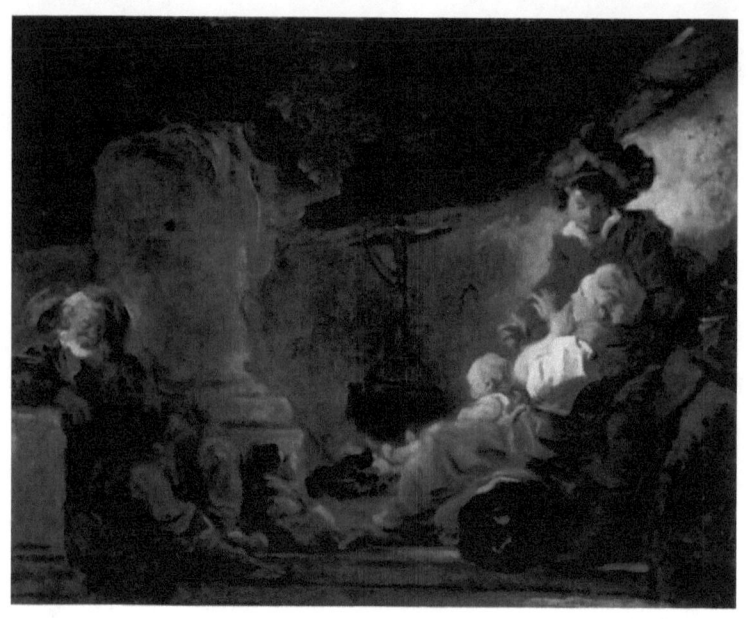

Night Scene, 1765-68, Oil on canvas, 74 x 92 cm

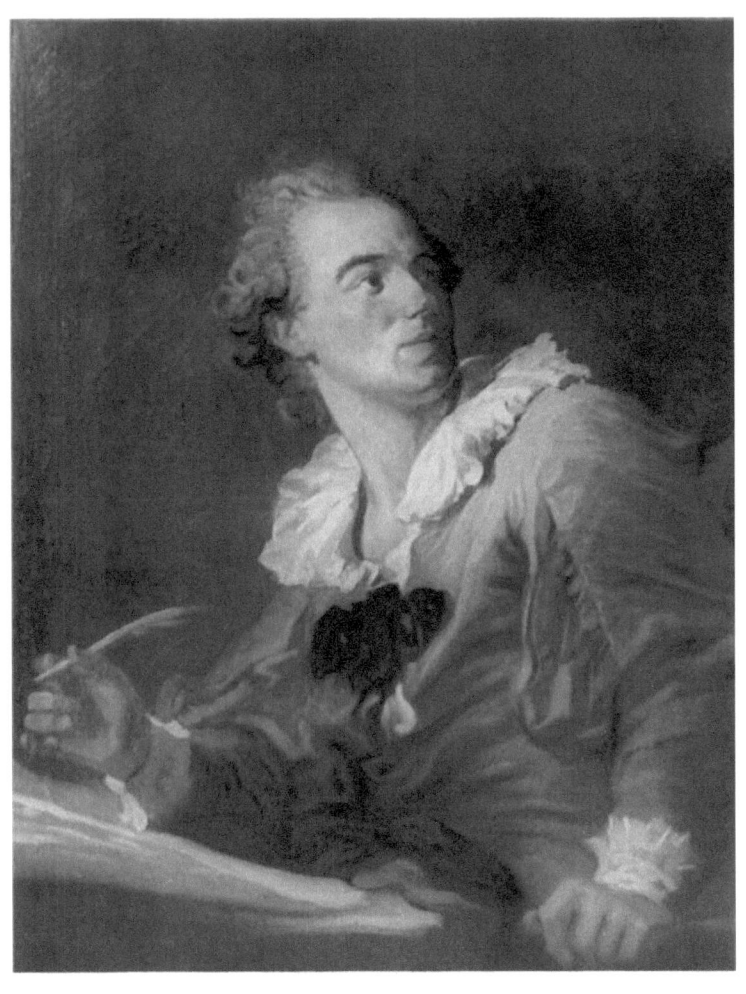

Inspiration, 1769, Oil on canvas

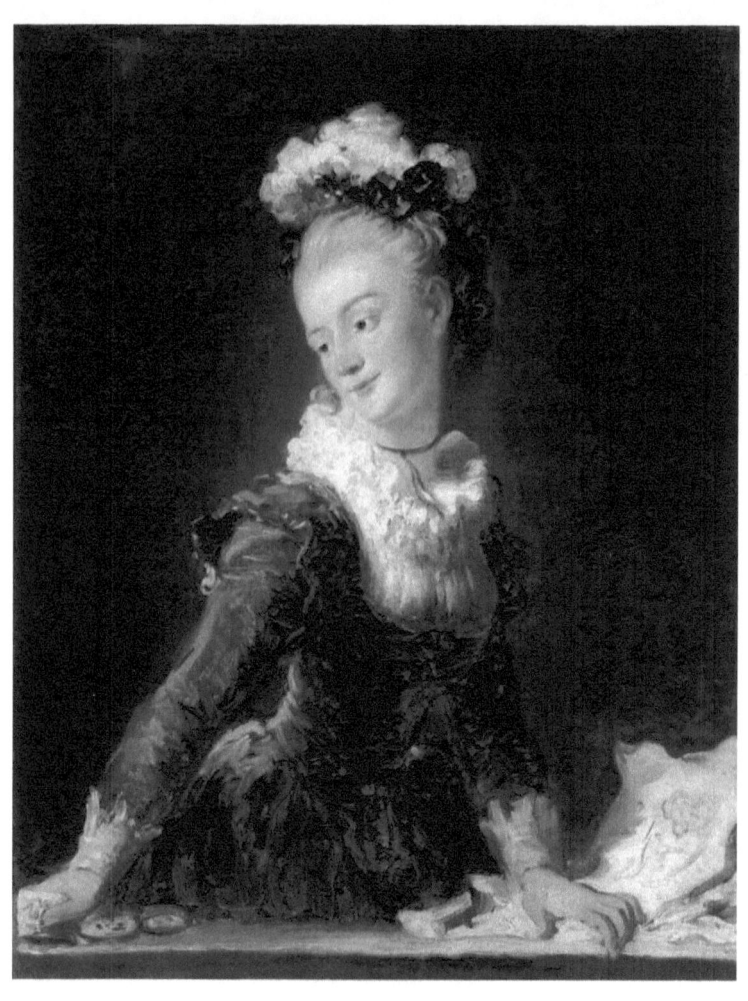

Marie Madeleine Guimard, c.1769, Oil on canvas

In 1769, Fragonard painted fourteen "fanciful figures" eight of which are now in the Louvre. These spirited portraits, whether painted from life or invented, with highly coloured faces and broad strokes of red and gold, represent the vision of an inspired poet capturing the essence of his subject, whether it is Diderot's ardent features or Mademoiselle Guimard's pleasing, if irregular face and arched bust in a burgundy bodice. Here Fragonard can be compared to Frans Hals or Rembrandt, because his artistic initiatives were nourished by an unusual degree of cultivation. Mademoiselle Guimard was a dancer.

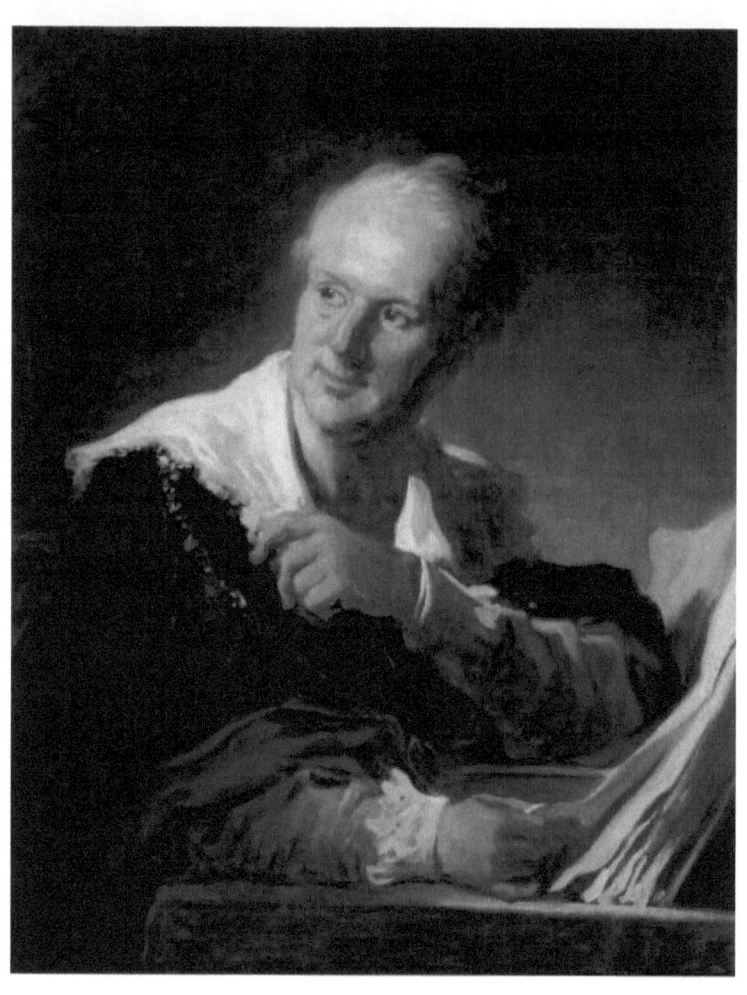

Portrait of Denis Diderot, c.1769, Oil on canvas

At the time this portrait was painted, Denis Diderot was one of the most famous literati in Paris. As the editor and publisher of the Encyclopedie, and author of many articles, novels and pieces of art criticism, he had great reputation. His competence as a critic was founded on immense reading. From aristocratic Rococo culture to the bourgeois ethic of virtue, his books and articles accompanied the whole of French art production under the ancien regime.

Fragonard's portrait of Diderot is part of his series of 'figures des fantaisies,' which was being built up at this time and depicts people in particularly inspired moments. Diderot himself had, on the occasion of another portrait, demanded the "grace of action". He wanted an action appropriate to the activity of the sitter, one which characterized him. The supreme commandment here was truth and naturalness of presentation. The action and pose were to be demonstrated with natural gestures. The ideal, for Diderot, was solitude in an unobserved moment, and the portrait was to simulate this. And as an unobserved genius in a state of inspired thought-production is also how Fragonard depicts him. This is a familiar enough genre, but Fragonard stages the enthusiasm of literary ideas with his impulsive painting technique and this combines the interest of the sitter with that of the beholder, a central concept in Diderot's theory of art.

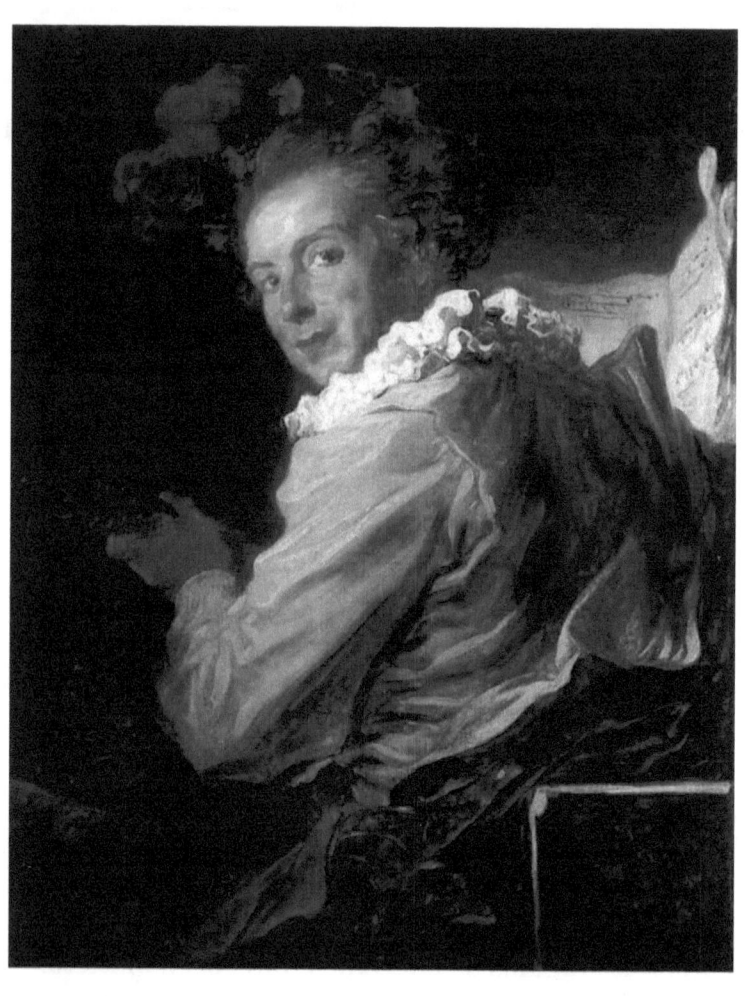

Portrait of Monsieur de la Breteche, brother of the Abbot of Saint Non, 1769, Oil on canvas

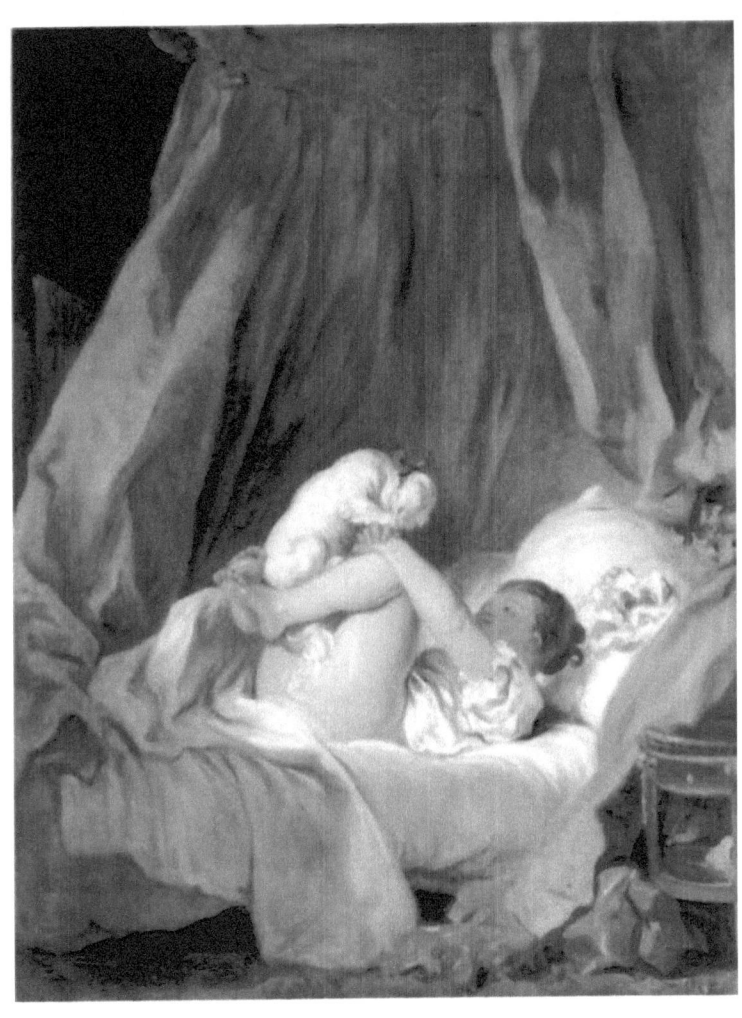

Girl with a Dog, c.1770, Oil on canvas

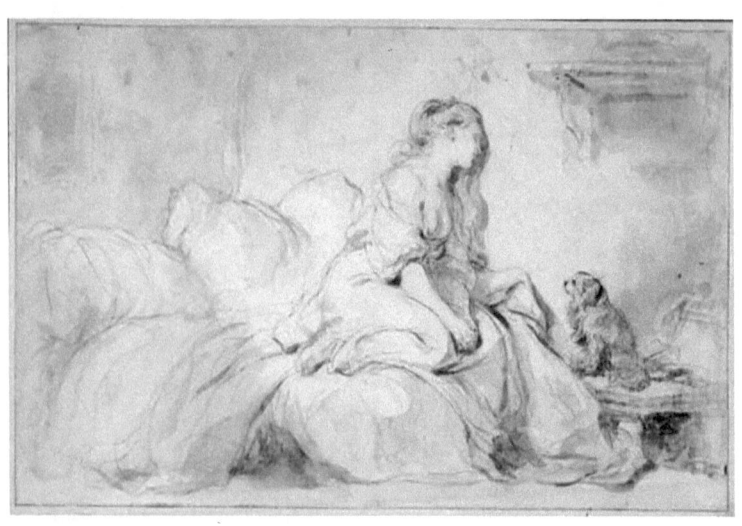

Oh! If only he were as faithful to me, 1770-1775, Black chalk, brush, and brown wash

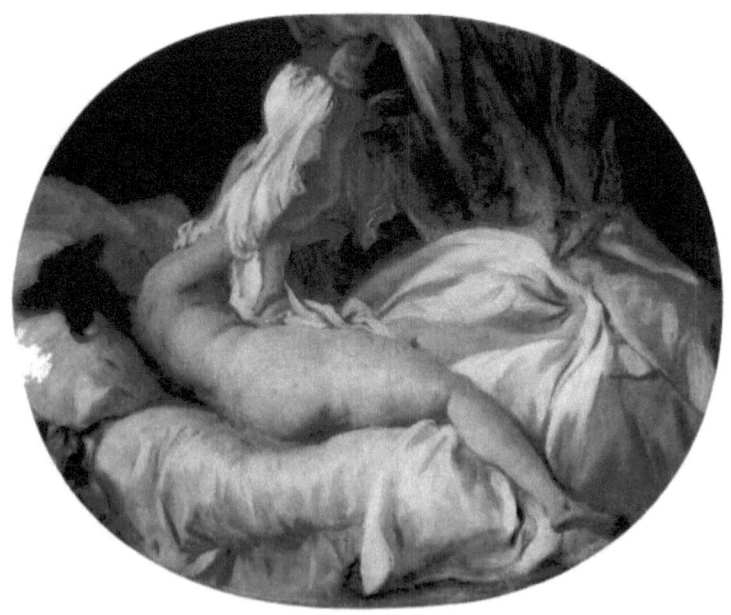

The Shirt Withdrawn, c. 1770, Oil on canvas, 35 x 42 cm

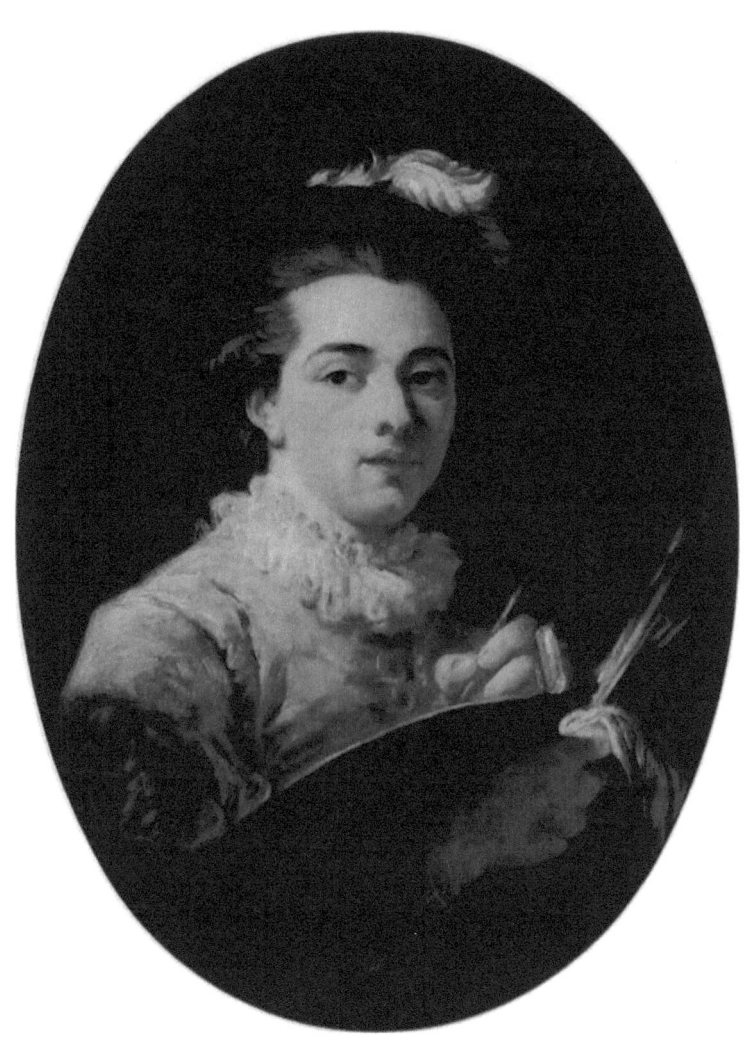

Self-portrait, c.1760-1770, Oil on canvas

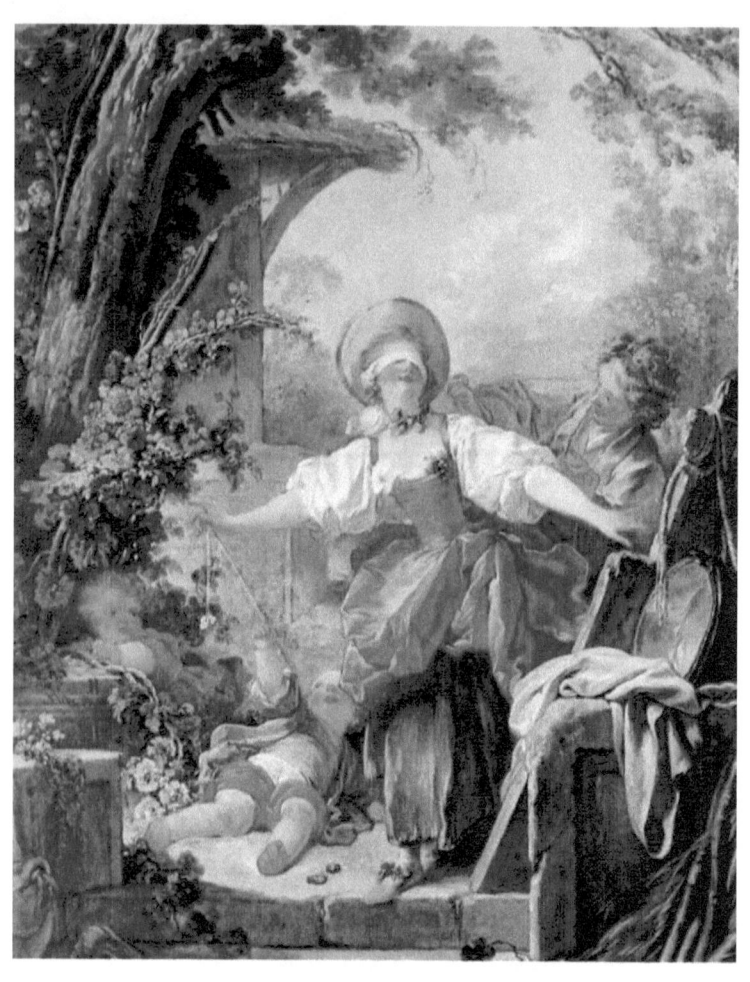

Blind Man's bluff, 1769-1770, Oil on canvas

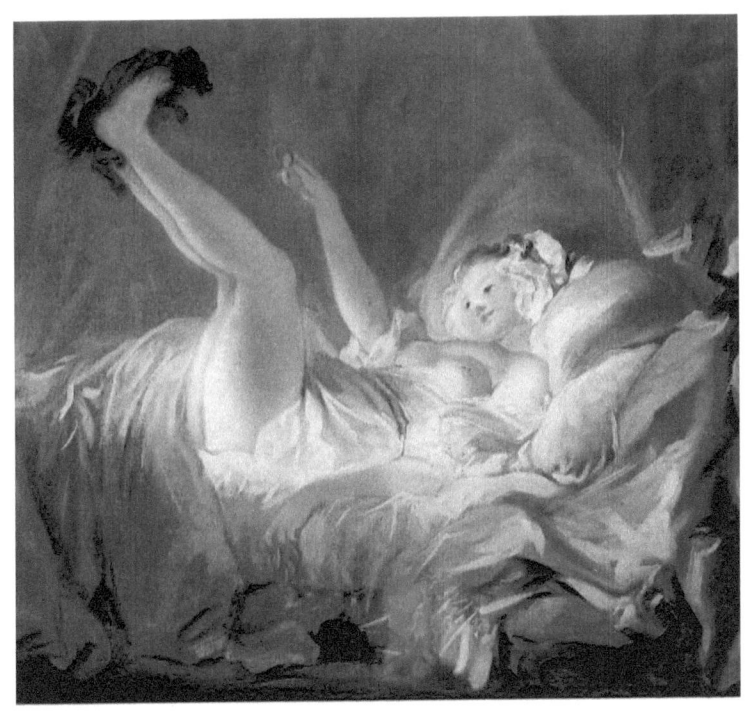

Young Woman Playing with a Dog, 1765-1772, Oil on canvas

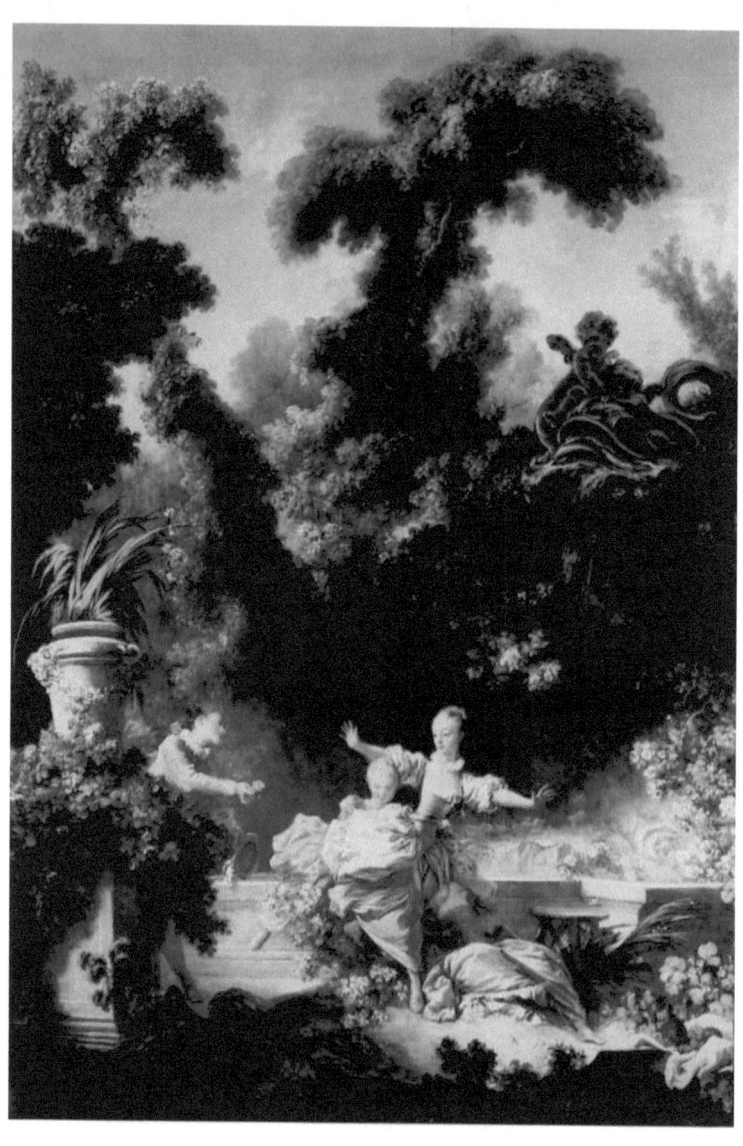

The Progress of Love; The Pursuit, 1773, Oil on canvas

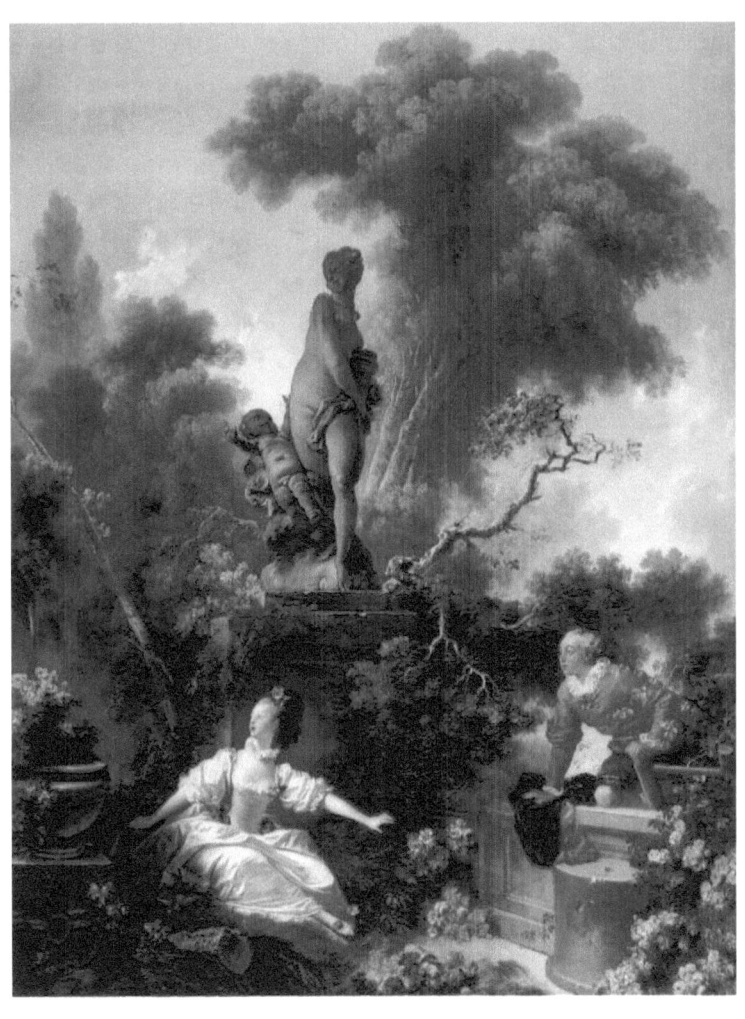

The Progress of Love: The Meeting, 1773, Oil on canvas, 318 x 244 cm

Madame du Barry commissioned Fragonard to do four panels for her salon at Louveciennes and he produced the delightful sentimental comedy of The Progress of Love, a kind of return to Watteau. But the year was already 1773 and the panels were criticised in a pamphlet that described them as "daubs." So Madame du Barry sends them back and turned instead to Vien. Fragonard was no longer fashionable.

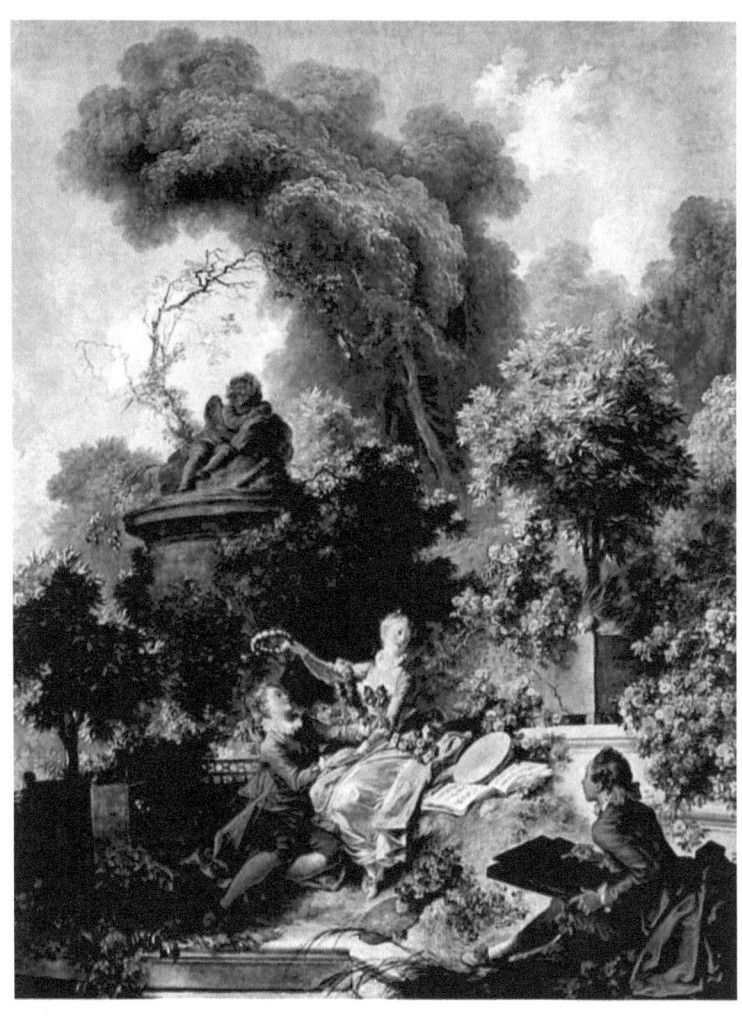

The Progress of Love: The Lover Crowned, 1771-73, Oil on canvas, 318 cm x 243 cm

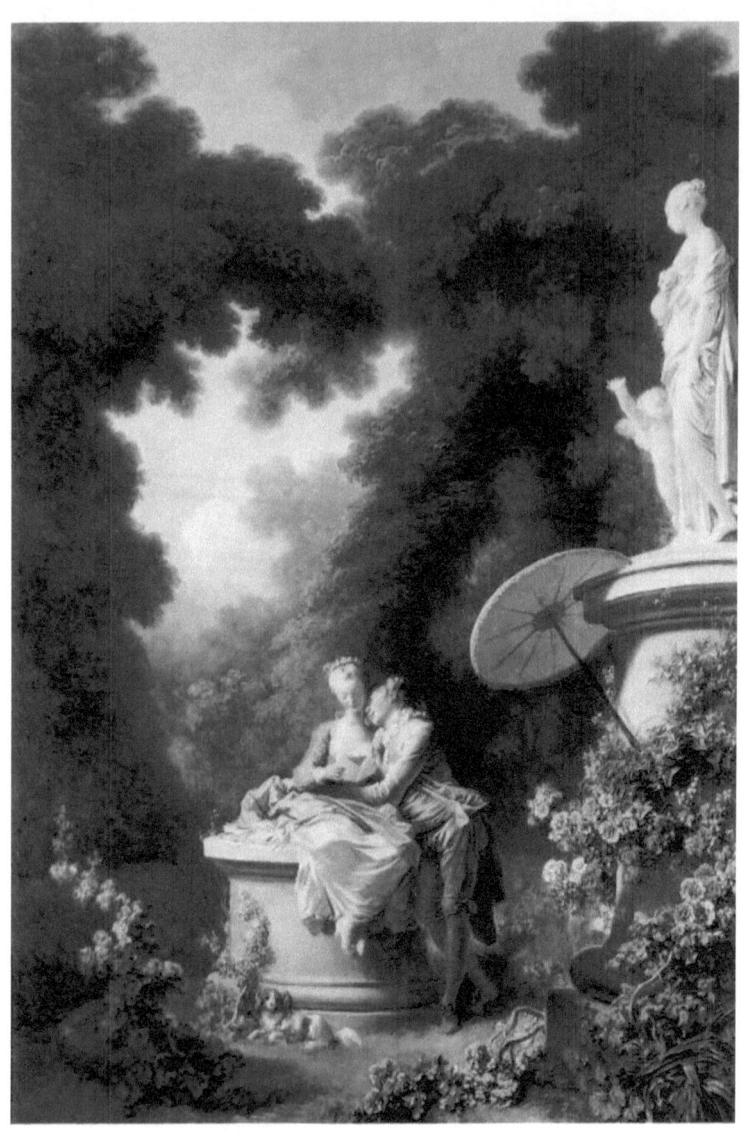

The Progress of Love: The Confession of Love, 1771-73,
Oil on canvas, 318 x 215 cm

The painting belongs to a series of four entitled Progress of Love. The cycle, often regarded as the artist's masterpiece, was painted for Mme du Barry, Louis XV's most beautiful mistress. The paintings, however, were returned by Mme du Barry since that time the taste has been already turned against Fragonard's lighthearted style.

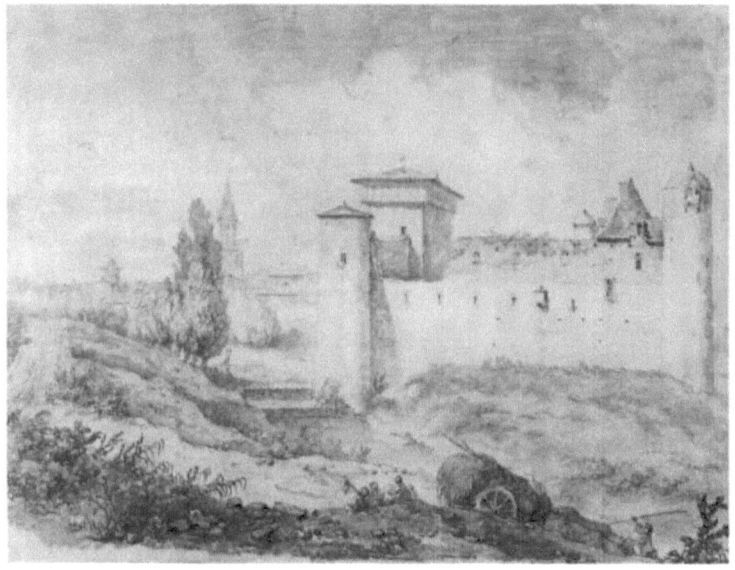

Castle Nègrepeliss, c.1773, Chalk

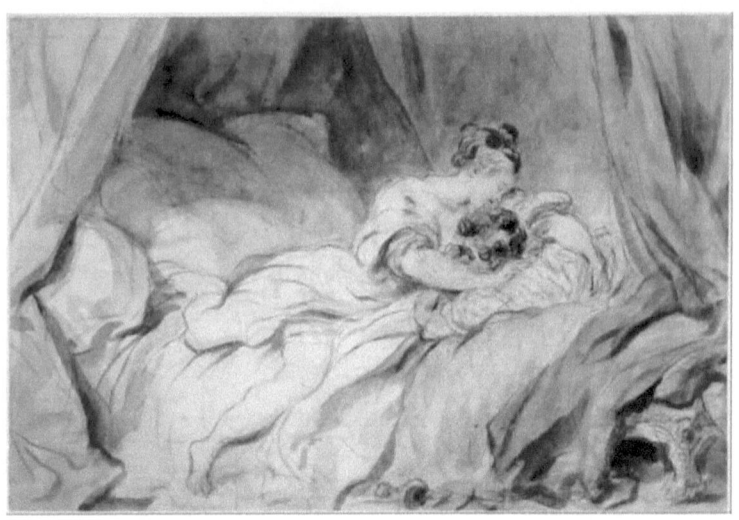

The Useless Resistance, 1773, Brush and washes over chalk underdrawing, watercolor, and opaque watercolor on paper

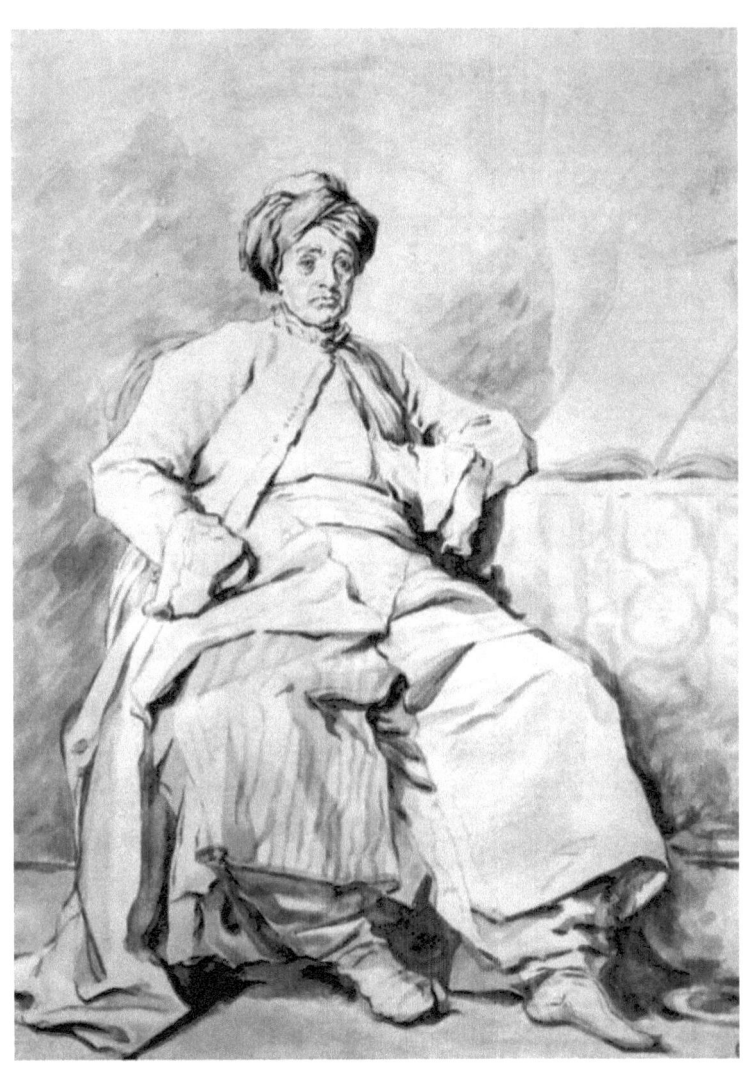

The Sultan, 1774, brush on white paper

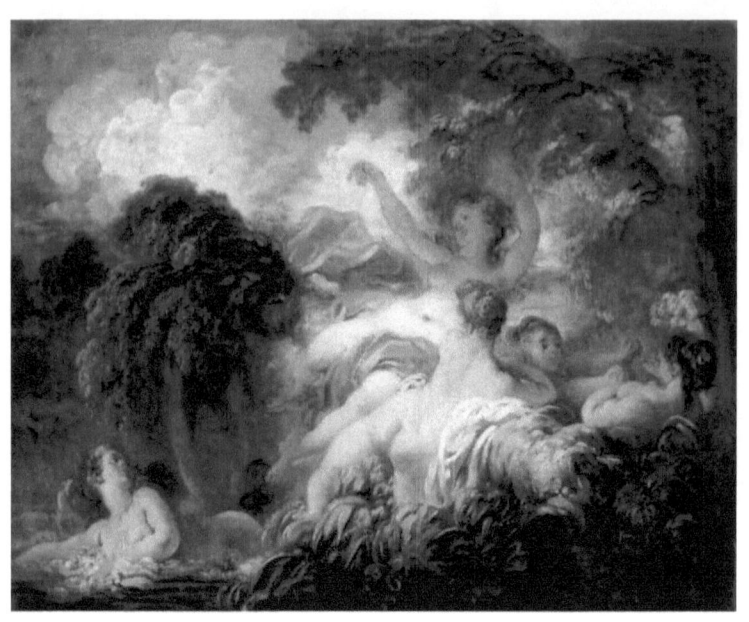

The Bathers, 1772-75, Oil on canvas, 64 x 80 cm

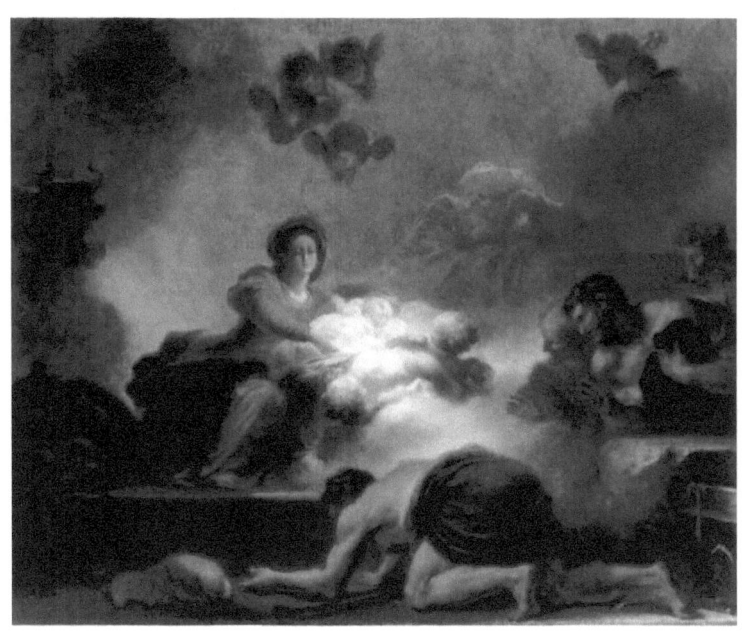

The Adoration of the Shepherds, c.1775, Oil on canvas

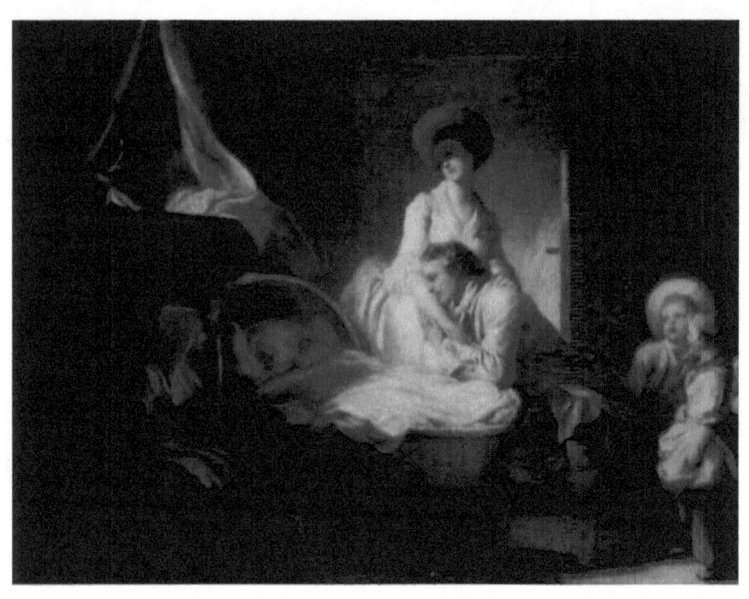

Visit to the nurse, c.1775, Oil on canvas

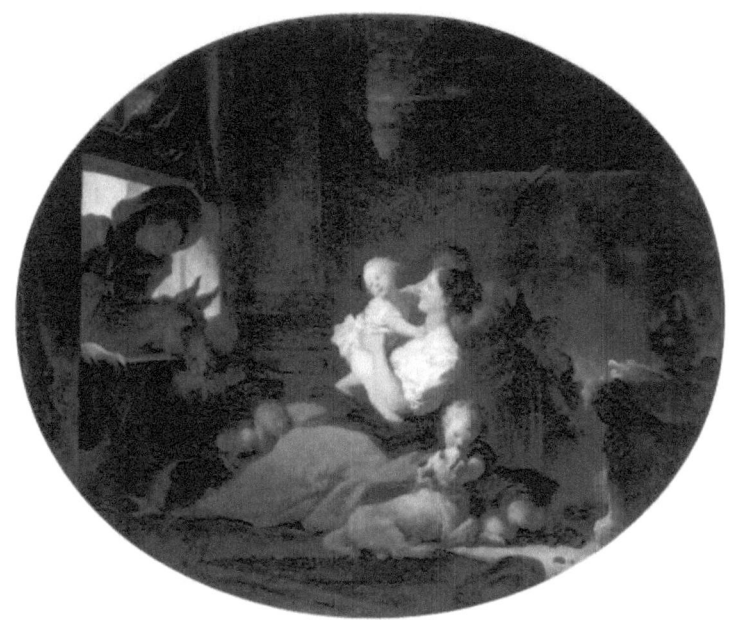

The Happy Family, c. 1775, Oil on canvas, 54 x 65 cm

The Happy Family must have been one of Fragonard's most popular compositions, for it is known in numerous variants and was engraved twice. The painting represents an interior of a room in which there is a woman and several children, and a man at the casement window.

The subject and the general composition of the painting recall the small genre scenes that Fragonard painted during his first trip to Italy, from 1756 to 1761, while he was a pensioner at the Academie de France in Rome. He seemed fascinated by the picturesque life in and around Rome, and he produced a series of paintings as well as innumerable drawings inspired by what he saw. Despite its resemblance to earlier works, however, The Happy Family and its variants are usually dated to the mid-1770s, after Fragonard's second trip to Italy in 1773-74.

Like other genre scenes painted by Fragonard in the 1760s and 1770s, The Happy Family bears the unmistakable influence of Greuze, the most innovative genre painter of the second half of the eighteenth century.

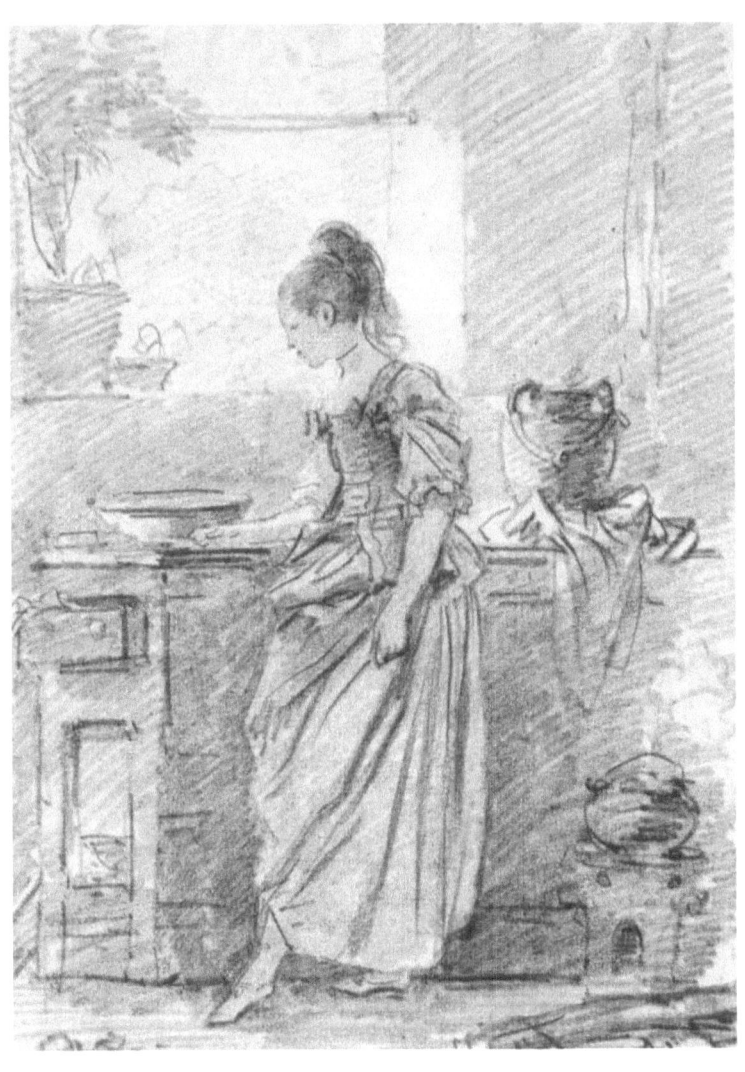

The Party Cook, c. 1775, Red chalk, 335 x 246 mm

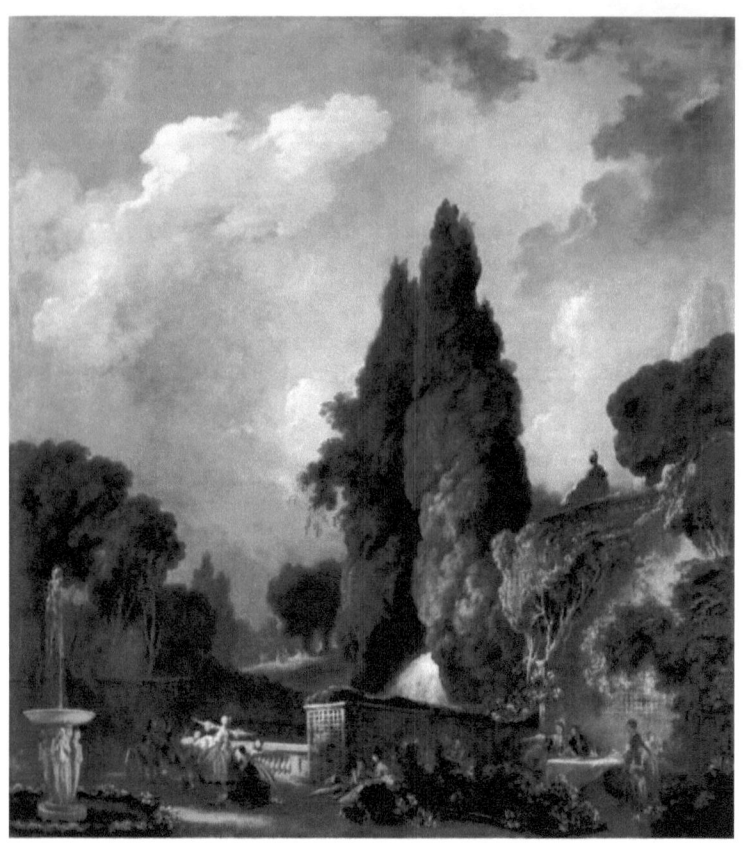

Blind man's buff, 1773-1776, Oil on canvas

The two large canvases, Blindman's Buff and The Swing, nearly identical in height, were part of a larger decorative scheme that included other garden scenes. They were conceived as decorations to be installed into the paneling on the wall of a salon.

The paintings present similar views of vast and fecund picturesque gardens, peopled with elegantly dressed men, women, and children playing games, conversing, promenading, and dining in an exuberant natural environment. These paintings must be counted among the greatest achievements in eighteenth-century French landscape painting.

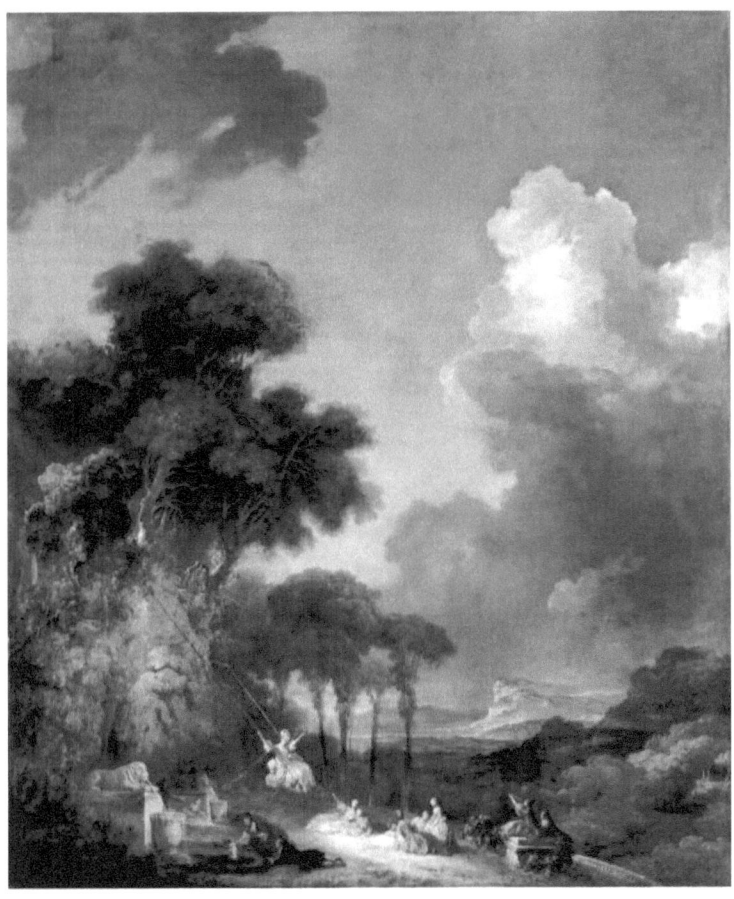

The Swing, 1773-76, Oil on canvas, 216 x 186 cm

Love as Folly, 1773-76, Oil on canvas, 56 x 47 cm

Fragonard repeated the compositions of the two small pendants known as Love as Folly, and Love the Sentinel numerous times during his career, two pairs are in the National Gallery of Art in Washington. The various versions of the compositions are usually dated to the early 1770s on the basis of style. Their light colour scheme, rapid brushwork, and lighthearted subjects are similar to numerous paintings, often in oval format that Fragonard produced in the years around 1770. During this period he was at work on his most celebrated cycle of decorative paintings, the large canvases called the Progress of Love, painted around 1771-72 at the request of Madame du Barry for her pleasure pavilion at Louveciennes outside Paris and now in the Frick Collection, New York. The present works related closely to two of four overdoors associated with this commission.

These compositions and their variants typify the kind of quickly painted, small-scale decorative pictures that Fragonard frequently produced during his career.

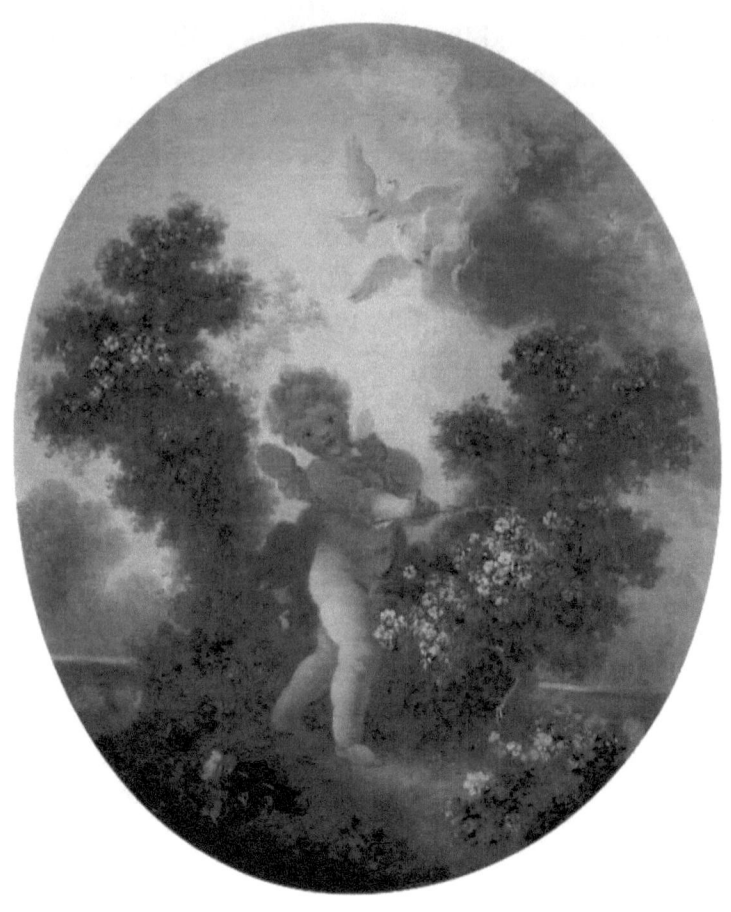

Love the Sentinel, 1773-76, Oil on canvas, 56 x 47 cm

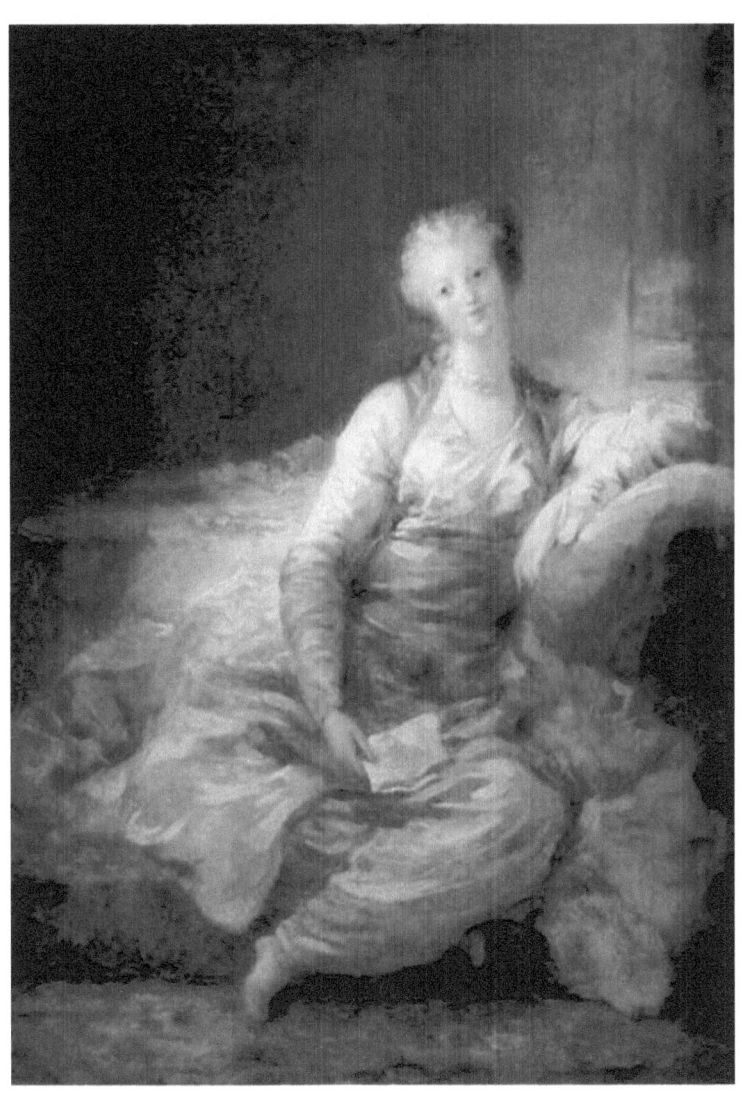

The little sultan, 1772-1776, Oil on canvas

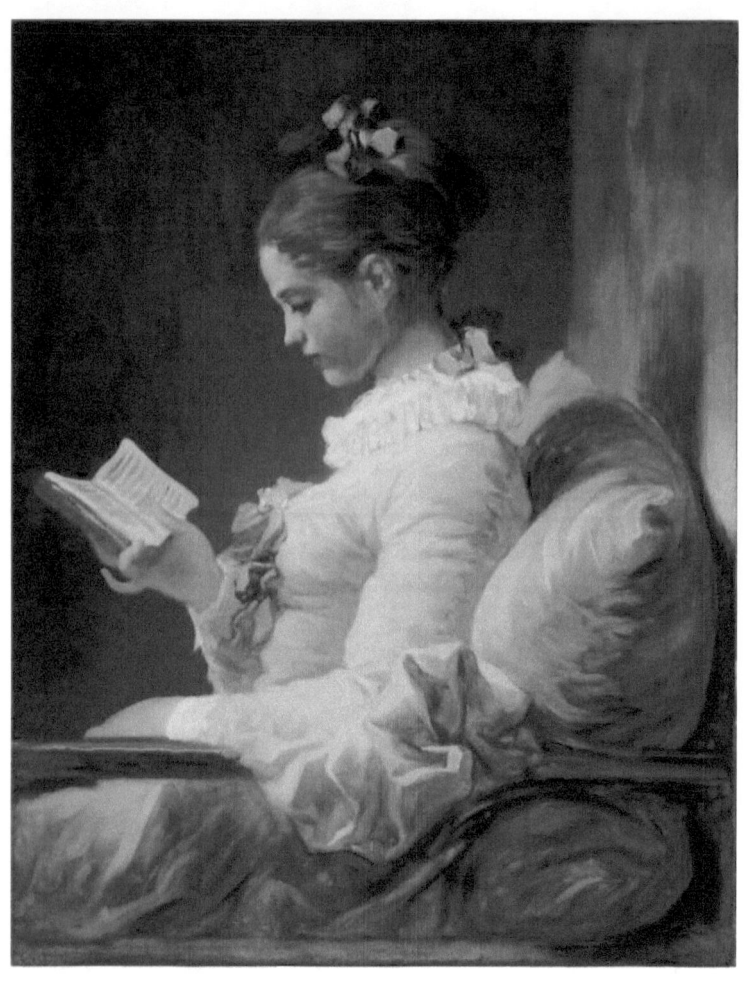

A Young Girl Reading, c.1776, Oil on canvas

Among Fragonard's most innovative compositions are his so-called 'portraits de fantasie,' a series of half-length figures of men and women dressed in fanciful costumes and usually accompanied by attributes or emblems of a profession or activity. The figures are invariable placed behind a ledge, tabletop, or other object that defines the interior space of the picture, and many turn dramatically and are brilliantly lit. Young Girl Reading has always been considered one of the series, although it does not conform precisely to the dominant characteristics of the majority of the others. Few artists can have enjoyed painting more than Fragonard. The way he applied his paint in broad sensuous strokes, which have a life of their own, communicates the artist's pleasure to the spectator. The plumped cushion, graceful fingers, curling bows, and the ruffle incised with the end of the brush, all reveal a masterly control of paint.

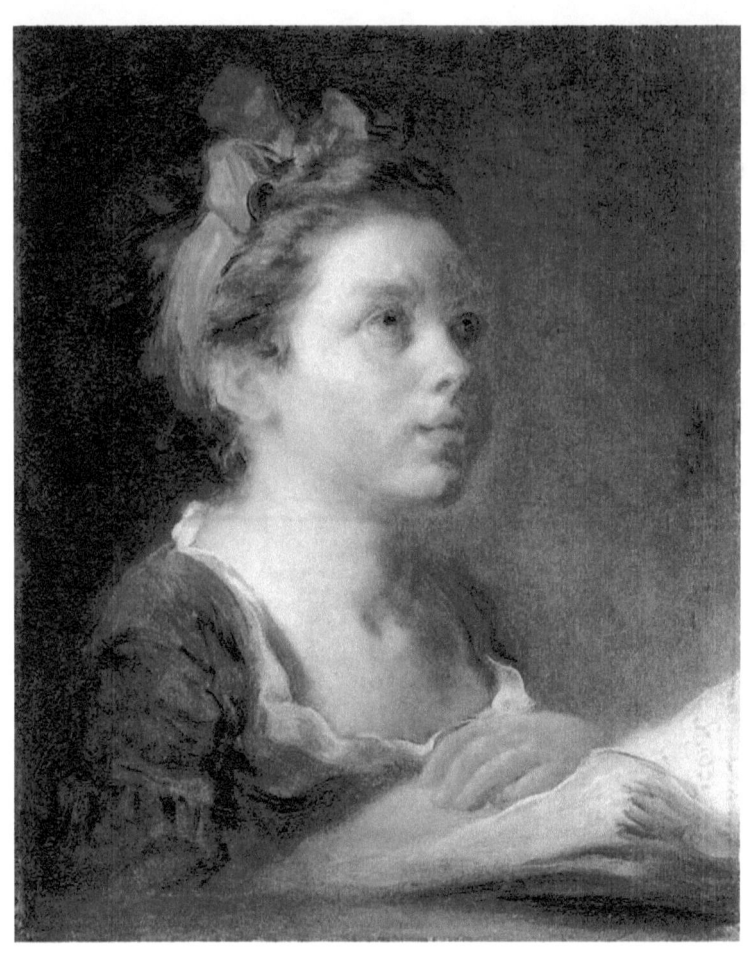

A Young Scholar, c.1775-1778, Oil on canvas

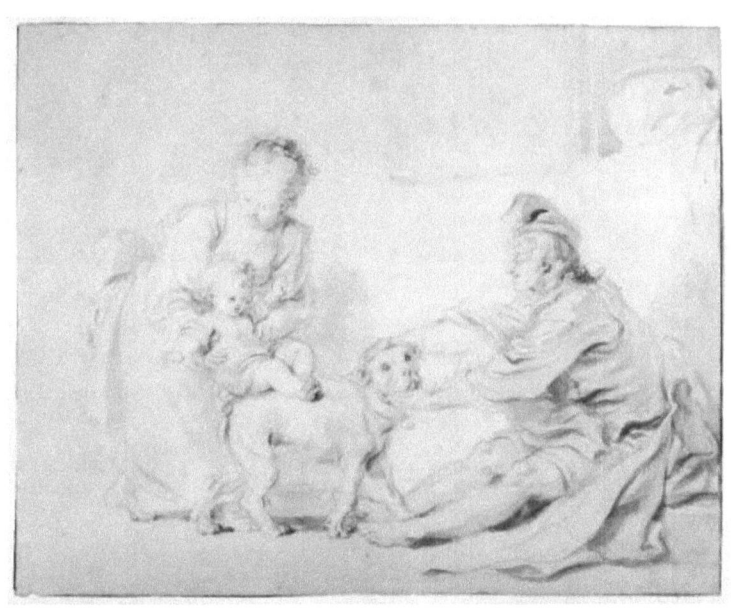

The First Riding Lesson, 1776-1780, graphite and brown wash on antique laid paper

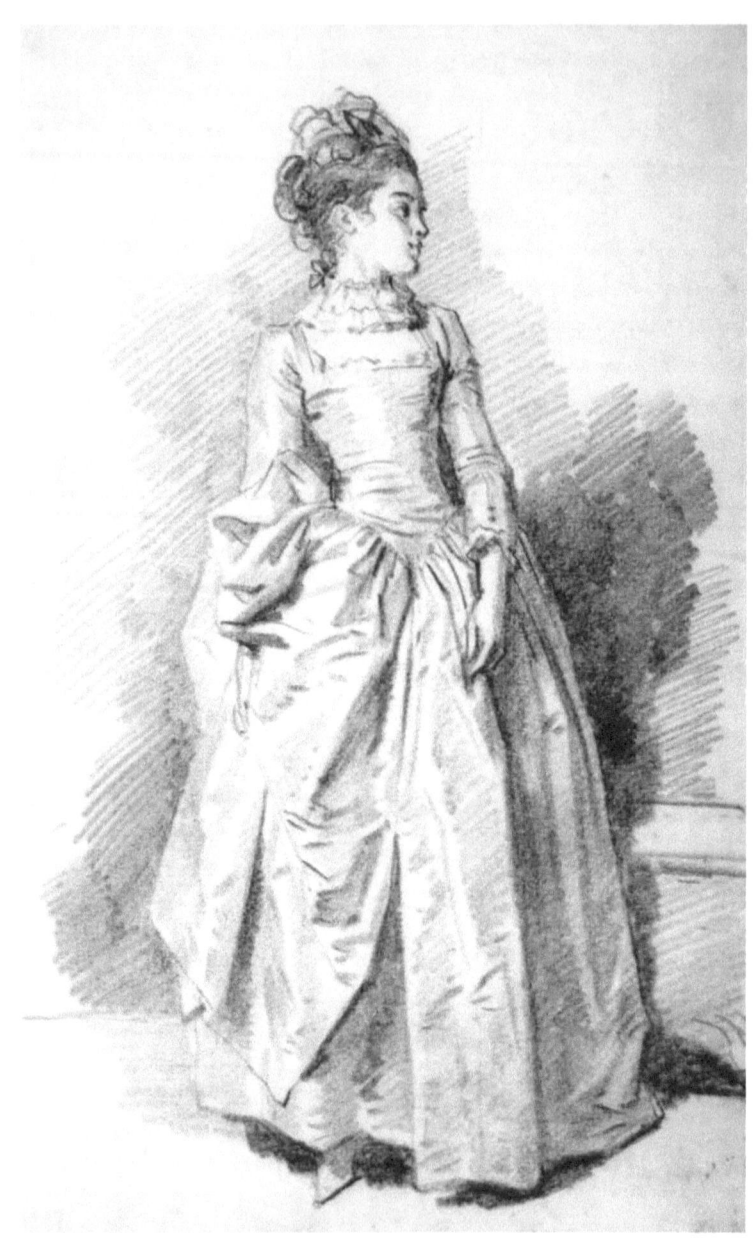

Young Woman Standing, 1775-85, Red chalk, 380 x 242 mm

Opinions differ as to the identity of this young woman, who is shown elegantly gathering up her skirts. It could be Fragonard's sister-in-law and pupil Marguerite Gerard or, as is nowadays believed, his daughter Rosalie. Fragonard took full advantage of his material, chalk, using a variety of contours, planes and shading to produce a charming portrait. His rendering of the satin material and the facial expression is particularly masterly.

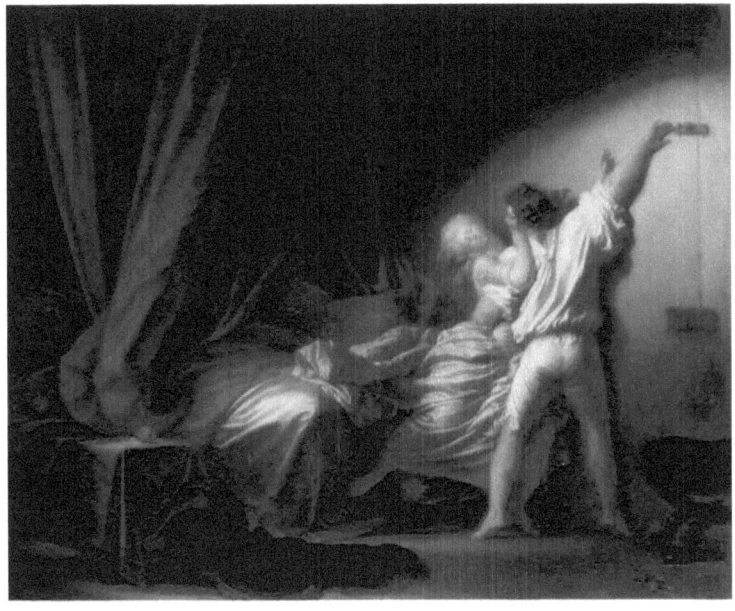

The Bolt, c.1778, Oil on canvas

At first sight, this painting describing the feminine resistance preceding abandons, might seem to belong to the same vein of light-hearted, erotic themes that Fragonard was fond of throughout his career.
However, the intensity of the chiaroscuro effects and the dramatic power of the diagonal composition, lend certain gravity to the scene.

Interestingly, this painting has a pendant illustrating sacred love, an Adoration of the Shepherds, also in the Louvre.

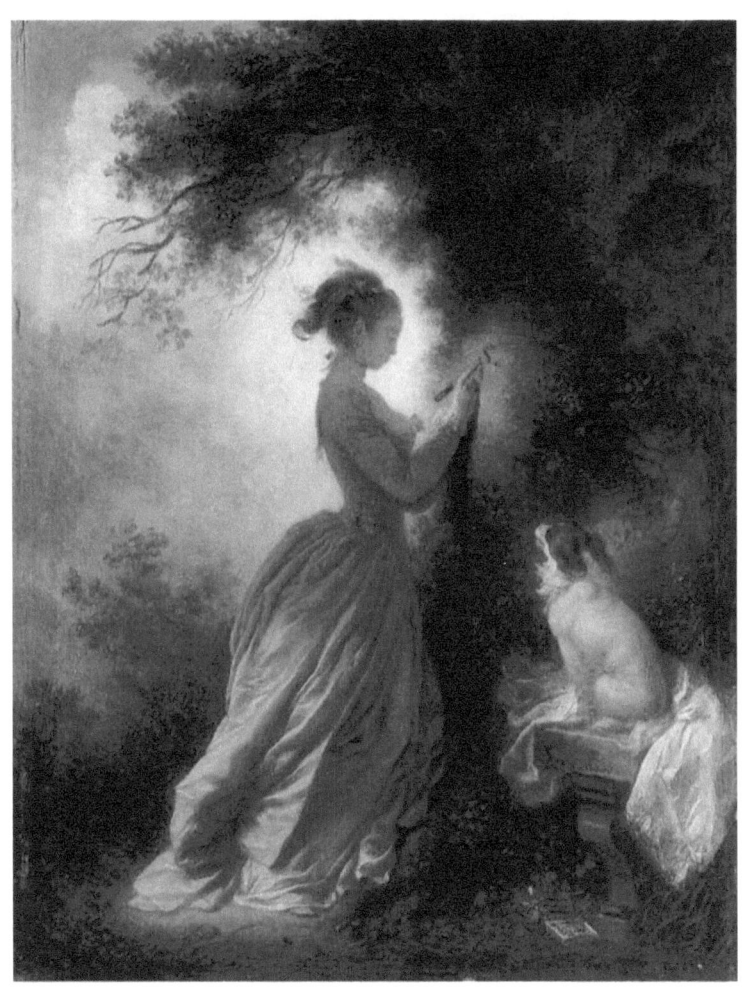

The Souvenir, 1775-1778, Oil on canvas
The girl carves in the tree the initials of her lover,
whose letter lies on the ground.

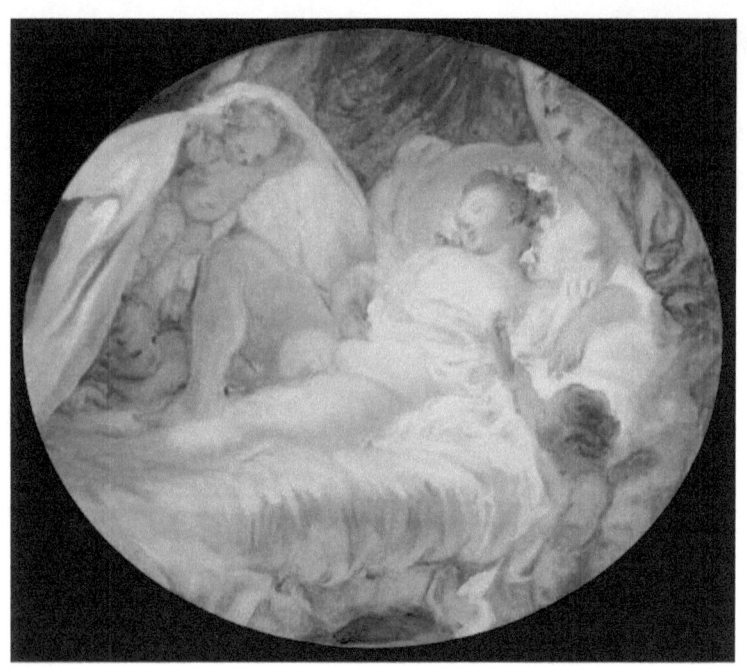

The Zenith, 1778, Oil on canvas

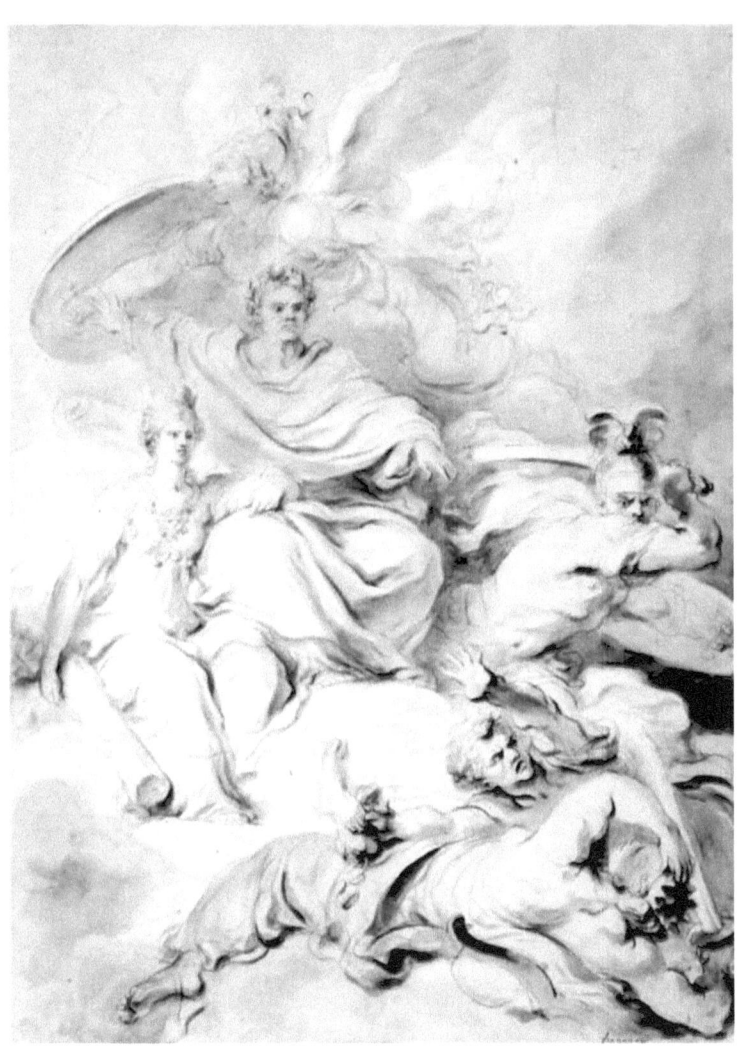

To the Genius of Franklin, c.1778, pencil, sepia

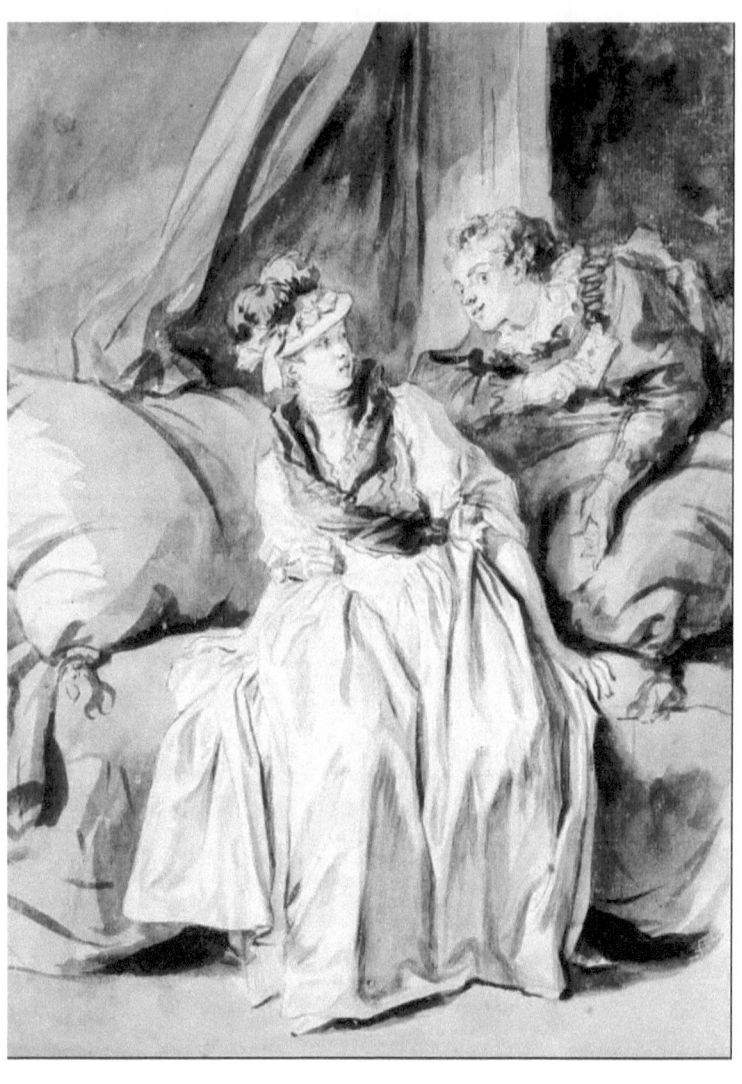

The Letter or The Spanish Conversation, 1778, Brush and brown ink and brush and brown wash, with graphite, on ivory laid paper

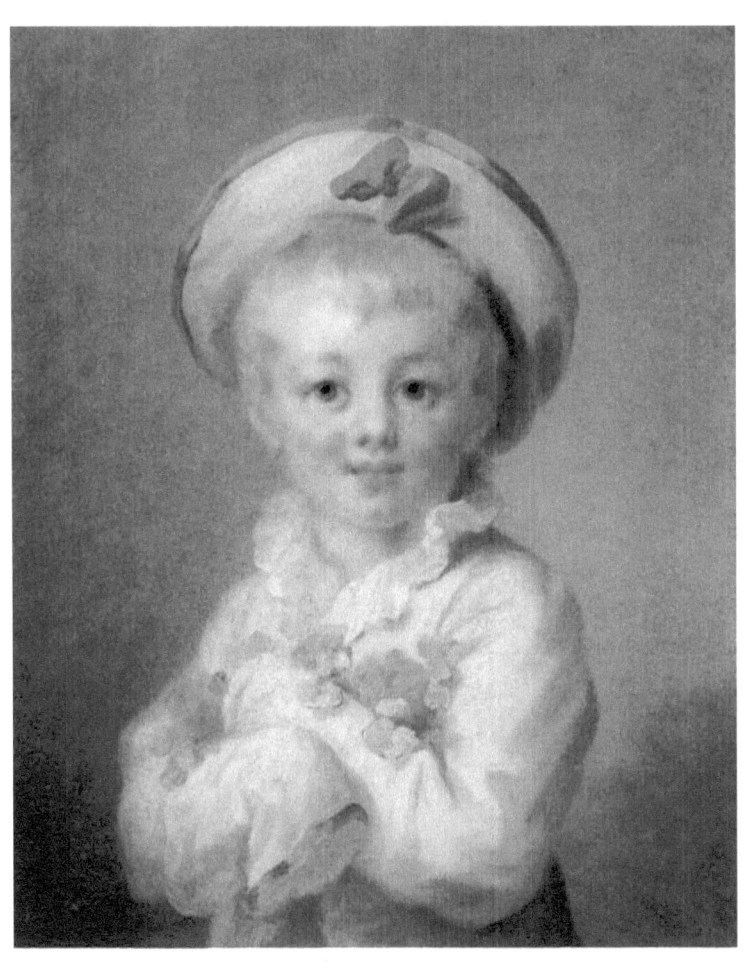

A Boy as Pierrot, c.1780, Oil on canvas

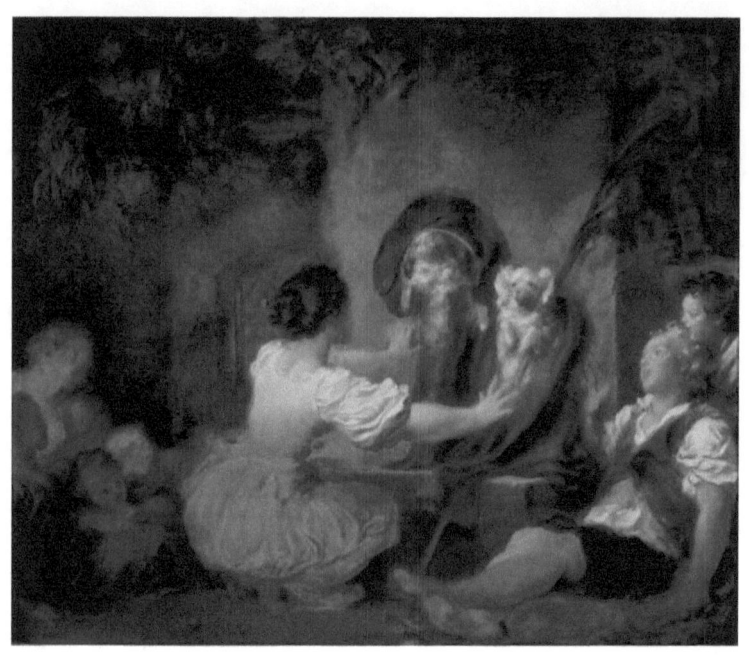

Education is all, c.1780, Oil on canvas

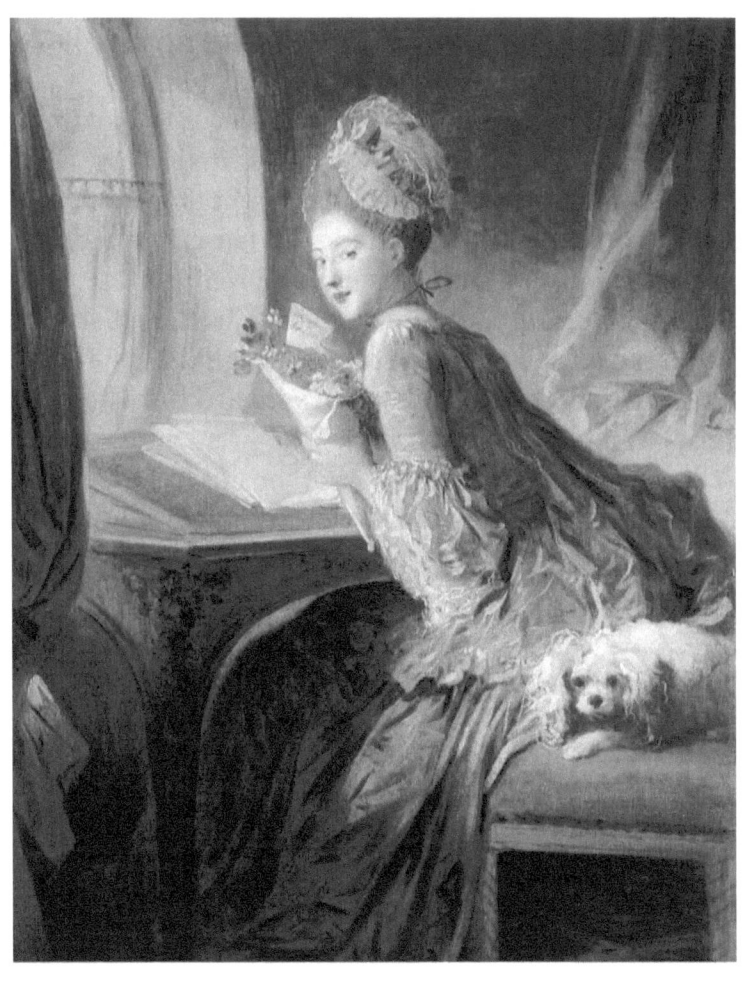

The Love Letter, c.1770-c.1780, Oil on canvas

This picture exemplifies Fragonard's feeling for colour, his sensitive handling of effects of light, and his extraordinary technical facility. The elegant blue dress, lace cap, and coiffure of the woman seated at her writing table must have been the height of fashion at the time this painting was made. The inscription on the letter she holds has given rise to different interpretations. It may simply refer to her cavalier, but if it is read Cuvillere, then the sitter would be the daughter of Franӡois Boucher, Fragonard's teacher. Marie Emilie Boucher, born in 1740, was widowed in 1769 and married, in 1773, her father's friend, the architect Charles Etienne Gabriel Cuvillier.

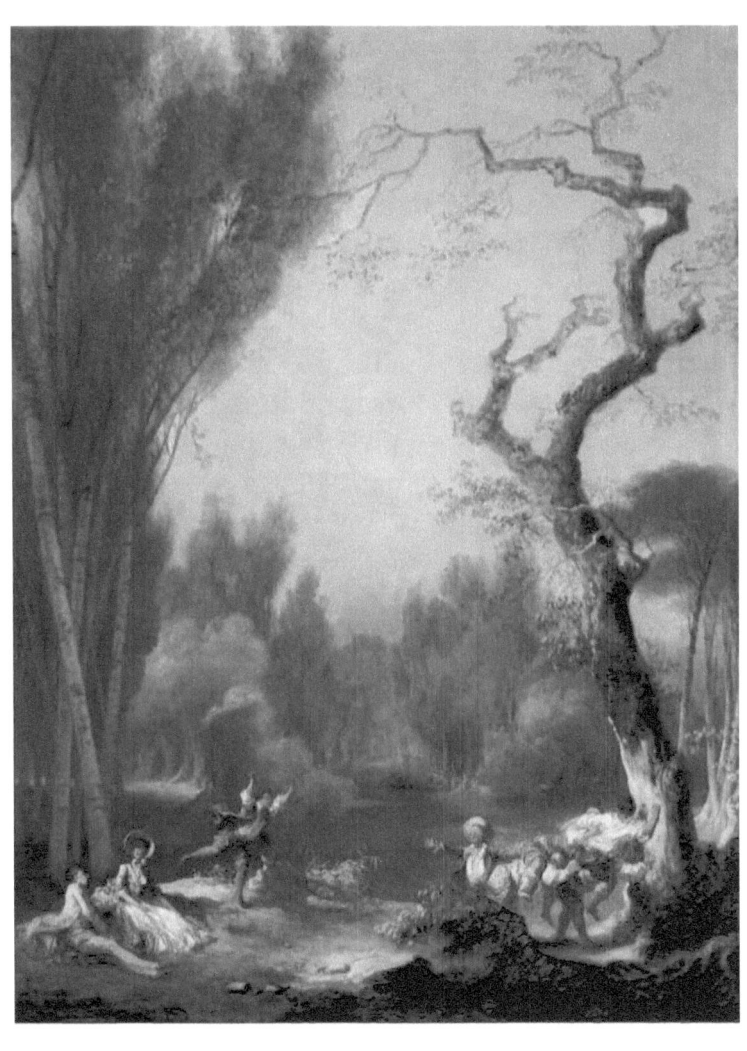

A Game of Horse and Rider, 1775-80
Oil on canvas, 115 x 88 cm

This painting is a pendant of A Game of Hot Cockles. The pendants were meant to be installed in boiseries as part of a larger decorative program. They are equal in size and have similar colour schemes and compositions, and their subjects are complementary; each focuses on richly verdant gardens in which groups of figures have gathered to enjoy games in the outdoors.

The two games depicted in the pendants were common in Fragonard's time. In Horse and Rider, the players have divided into two teams, one acting as a multilegged "horse," bracing itself against a tree; the second team consists of "riders" who run and leap, one by one, onto the back of the "horse." Once they are all aboard, the horse team tries to shake them off.

The game is played in a garden which is natural, with no signs of human manipulation; its principal motif is a gnarled and twisted tree.

The pendants owe a debt to Oudry, whose designs for a tapestry cycle on the theme of "Amusements champêtres" include representations of Horse and Rider and Hot Cockles that are closely related to Fragonard's compositions.

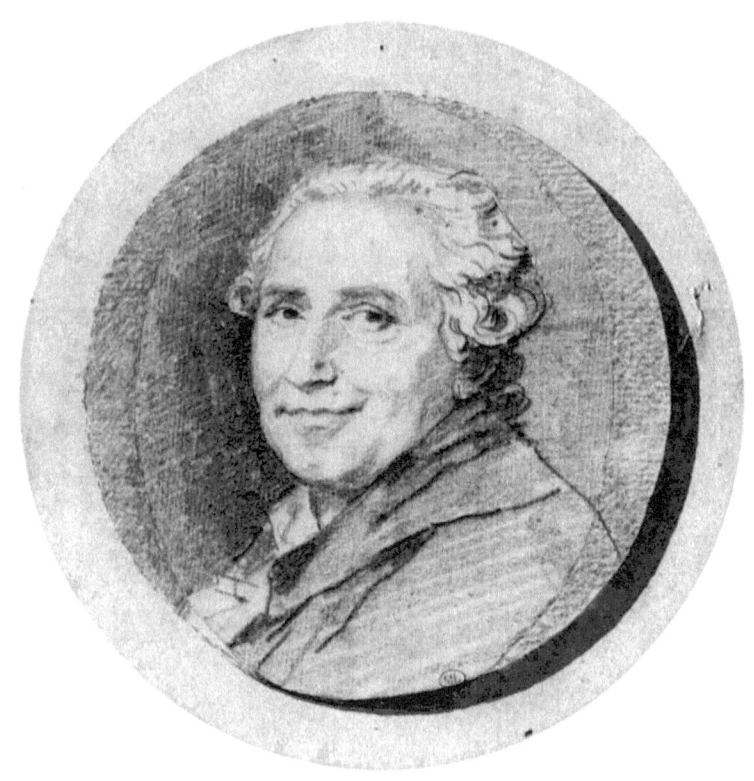

Self-Portrait Facing Left, 1780s, Black chalk

The few authentic portraits of Fragonard, including several self-portrait drawings, record the artist at an old age. An early nineteenth-century account describes Fragonard in later life as "plump, podgy, dapper, always bright and cheerful, he had fine rosy cheeks, sparkling eyes, a tousled mat of grey hair."

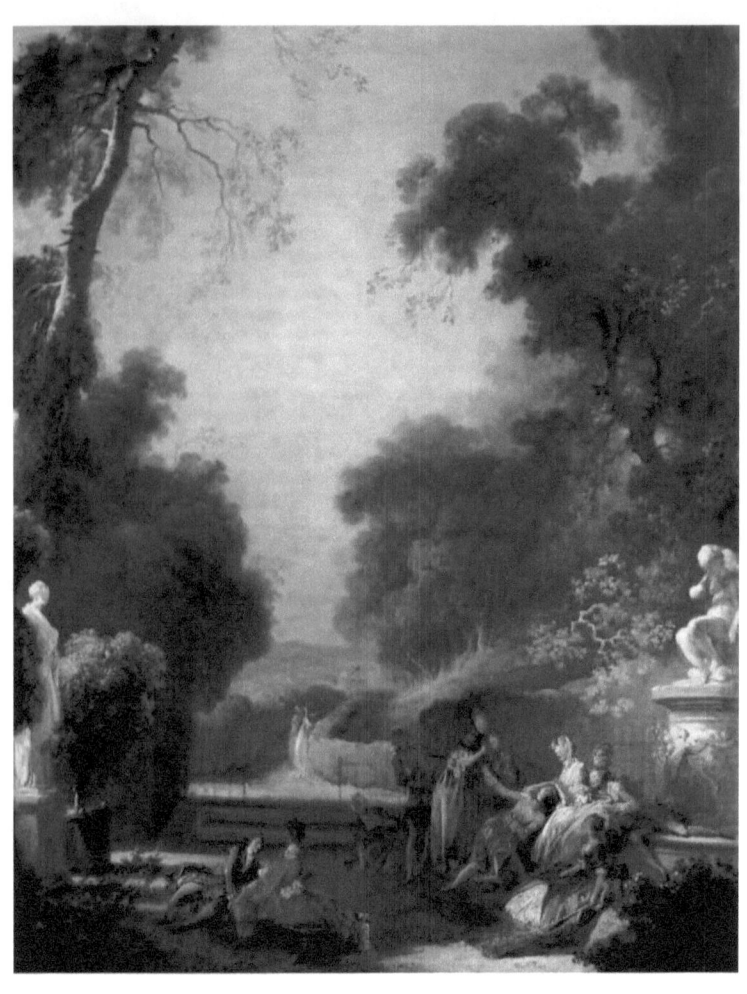

A Game of Hot Cockles, 1775-80
Oil on canvas, 116 x 92 cm

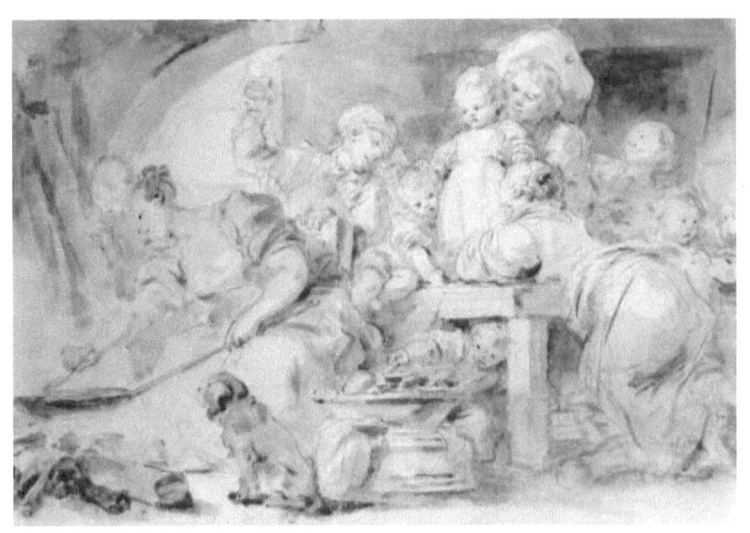

The Pancake Maker, 1782

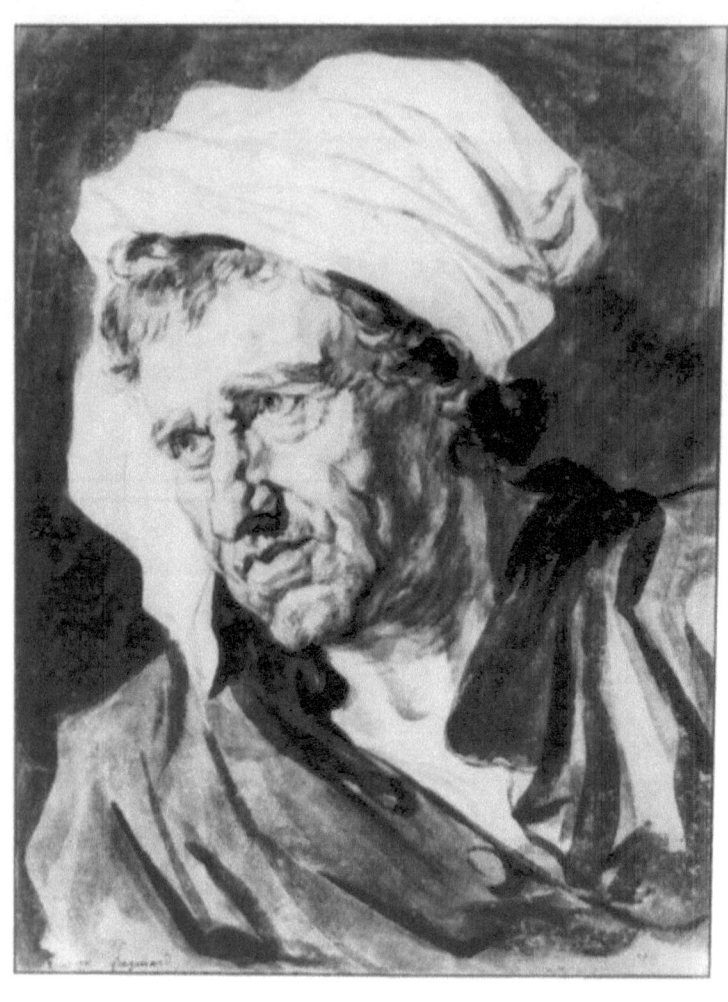

Head of a man with white turban, 1784, Brush in brown ink over chalk on paper

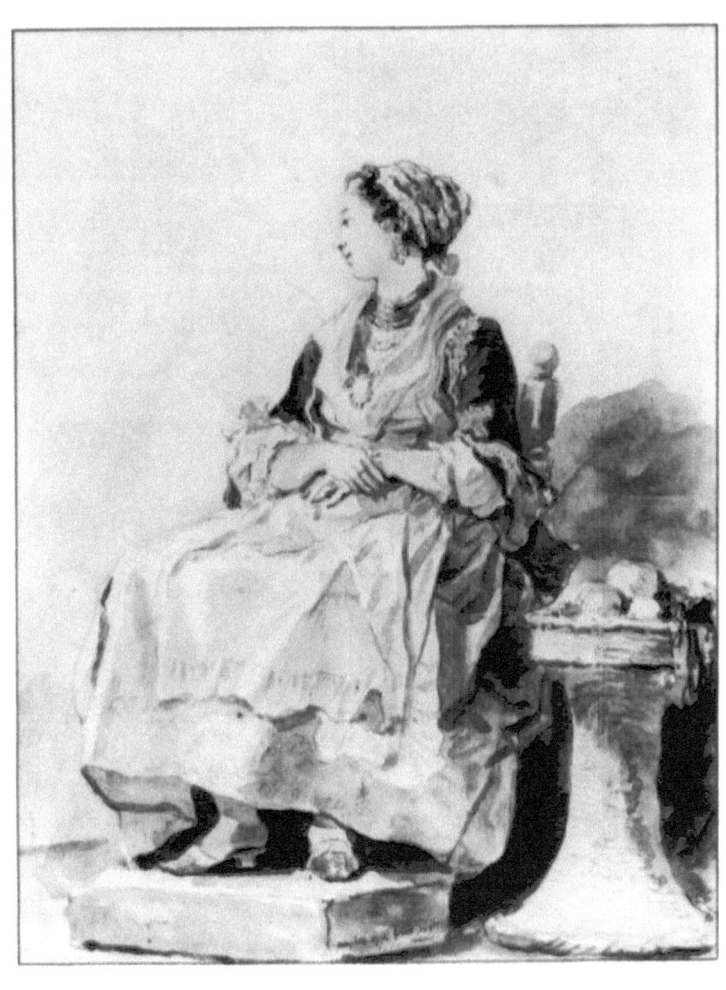

Neapolitan woman, sitting outdoors, 1784, Brush in brown ink over chalk on paper

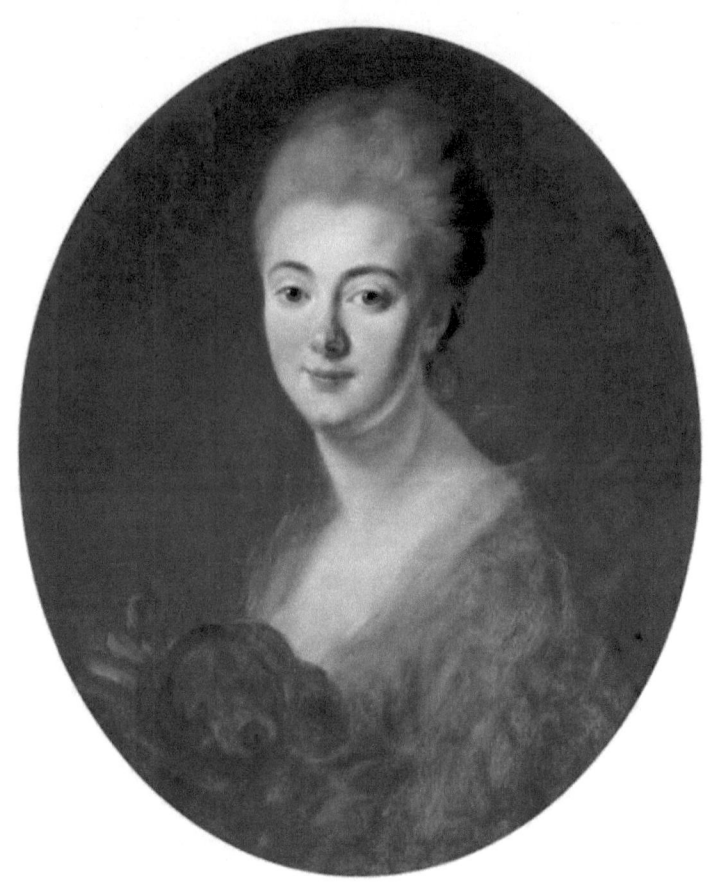

Portrait of Elisabeth Sophie Constance de Lowendhal,
1775-1785, Oil on canvas

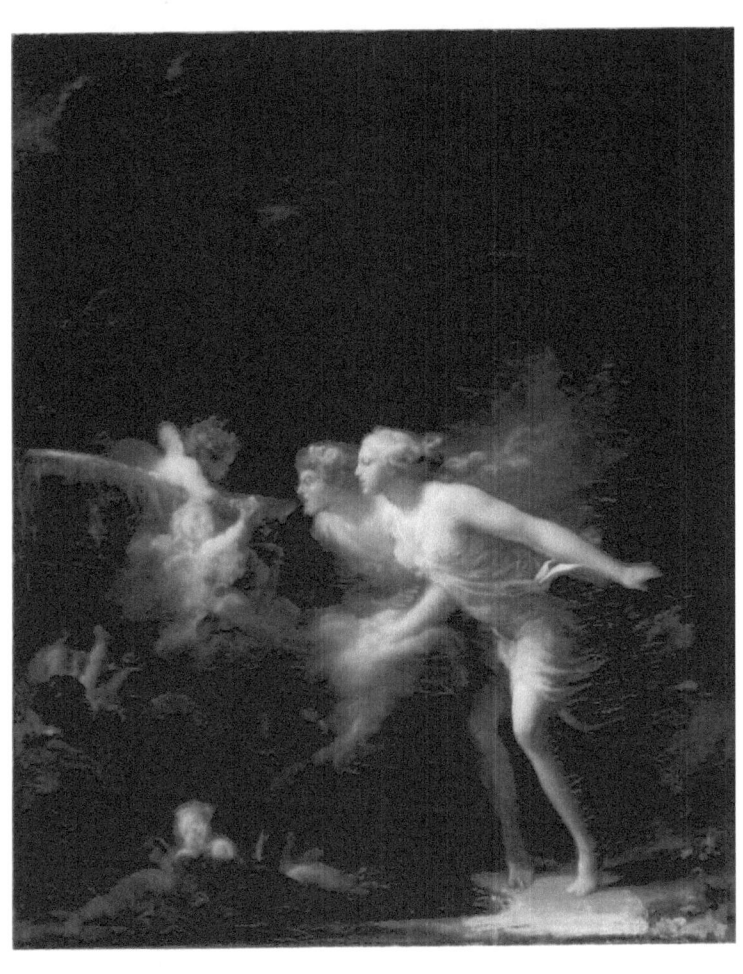

The Fountain of Love, c.1785, Oil on canvas

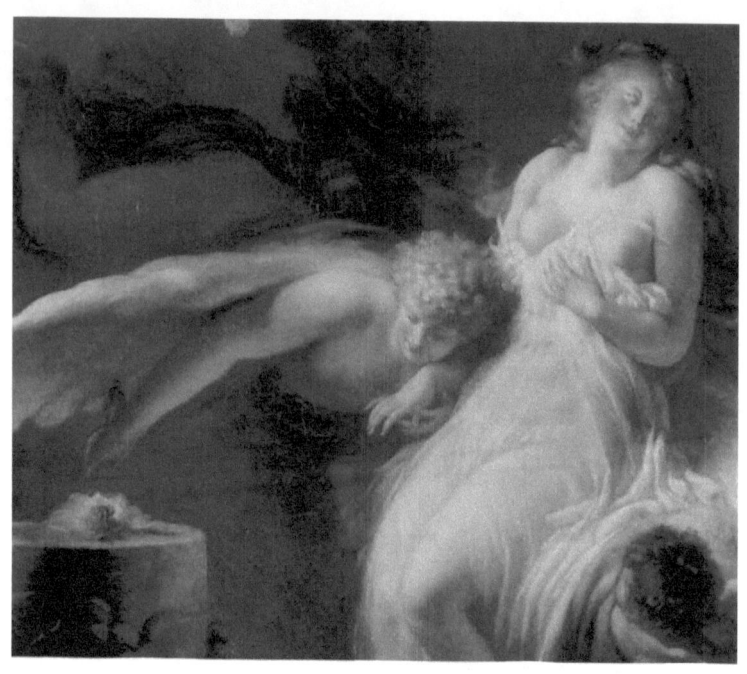

The Sacrifice of the Rose, Detail, about 1785-88, Oil on canvas

Illustration for Ariosto's "Orlando Furioso", 1787-1789,
Black chalk, brush wash in brown ink, on paper

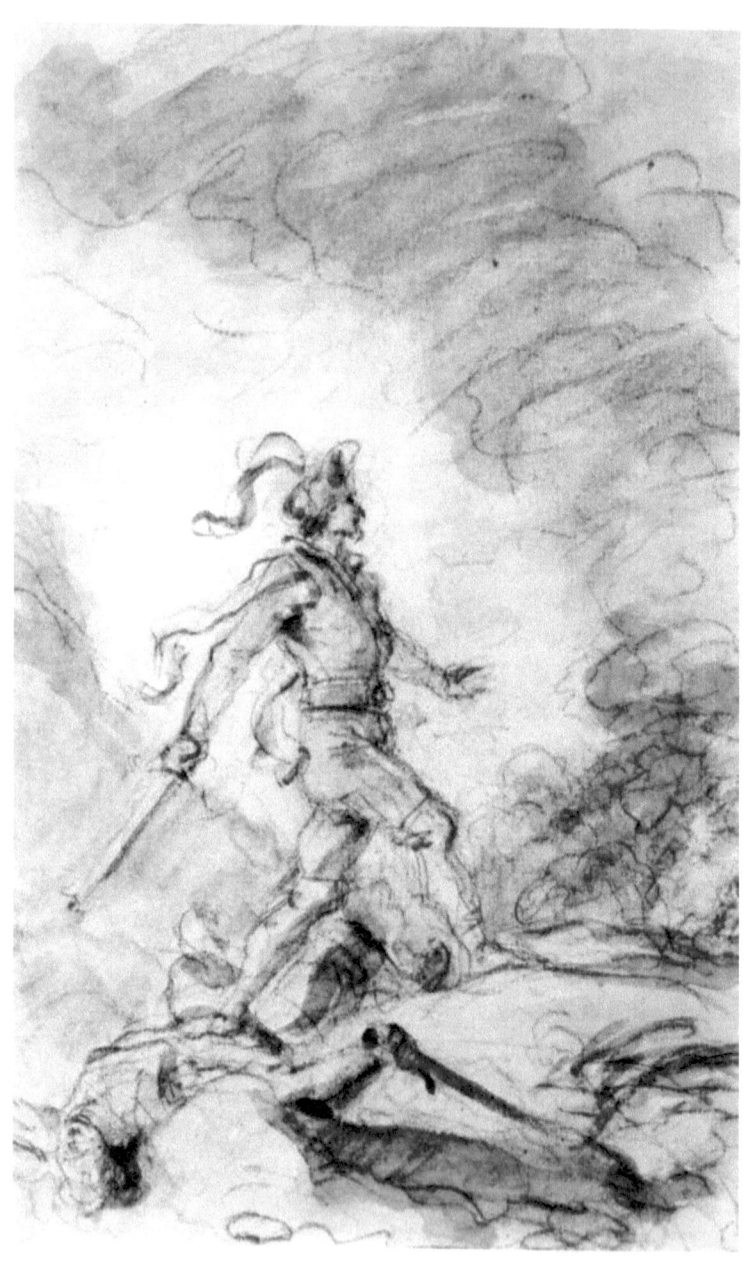

Illustration for Ariosto's "Orlando Furioso", 1787-1789,
Black chalk, brush wash in brown ink, on paper

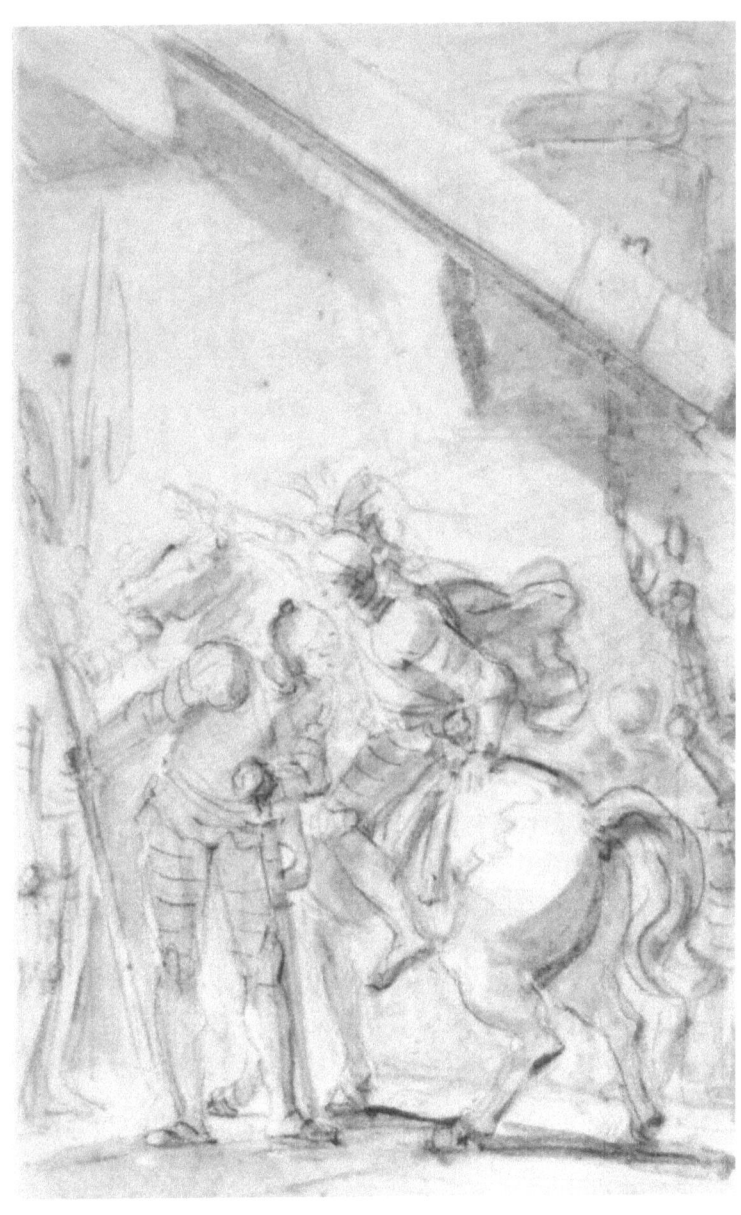

Illustration for Ariosto's "Orlando Furioso", 1787-1789,
Black chalk, brush wash in brown ink, on paper

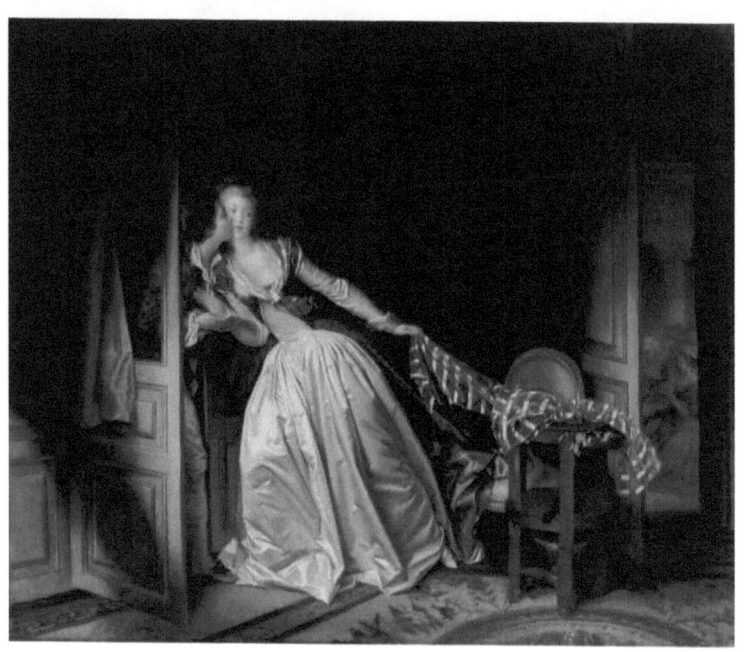

The Stolen Kiss, 1788, Oil on canvas

This late masterpiece by Fragonard shows the influence of the 17th-century Dutch painters such as Gabriel Metsu and Gerard Terborch. In a brief period before the French Revolution, Fragonard combined the seemingly incompatible: Dutch sensitivity to the texture of materials and nuances of light with Neoclassical stringency in construction.

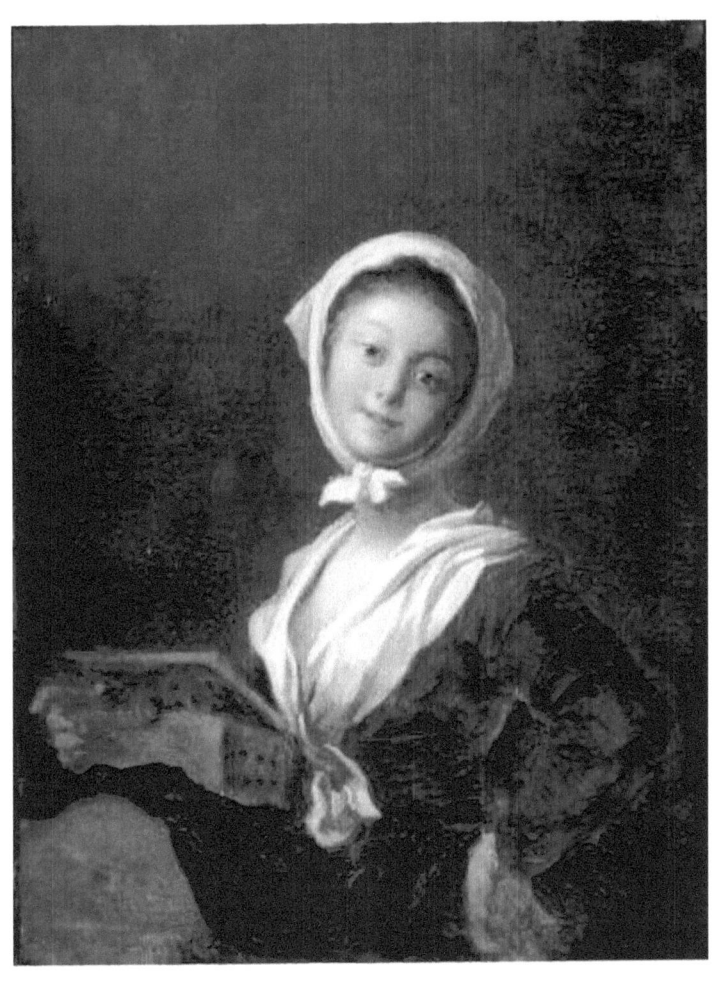

Girl with a Marmot, 1770-1790, Oil on canvas

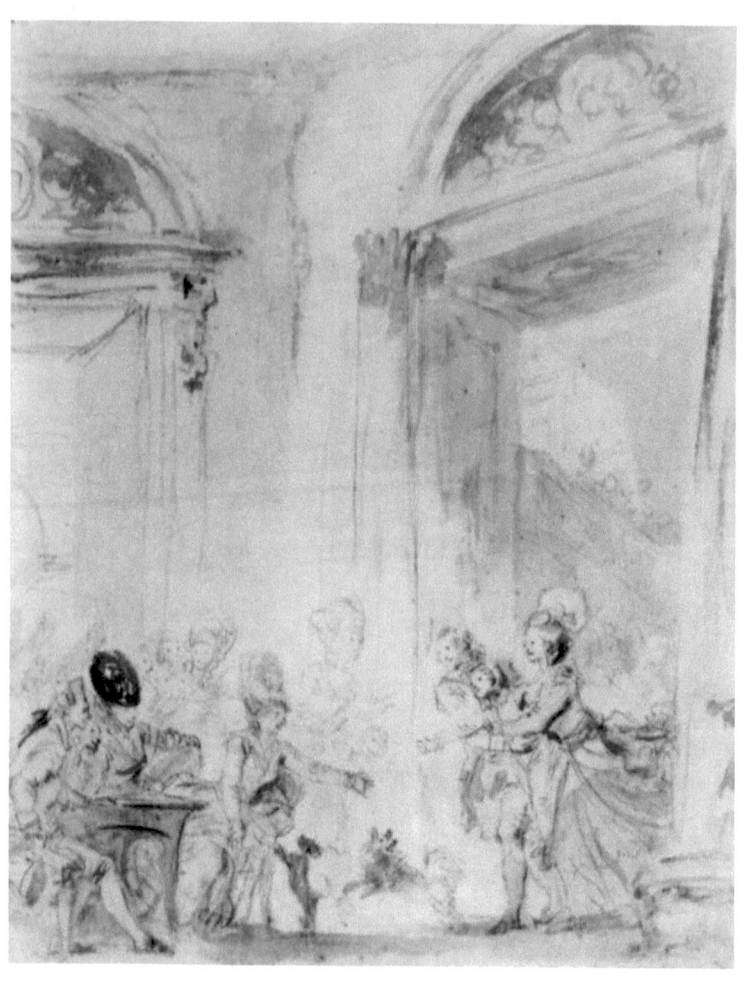

Children's scene, 1780–1790, ink drawing on chalk

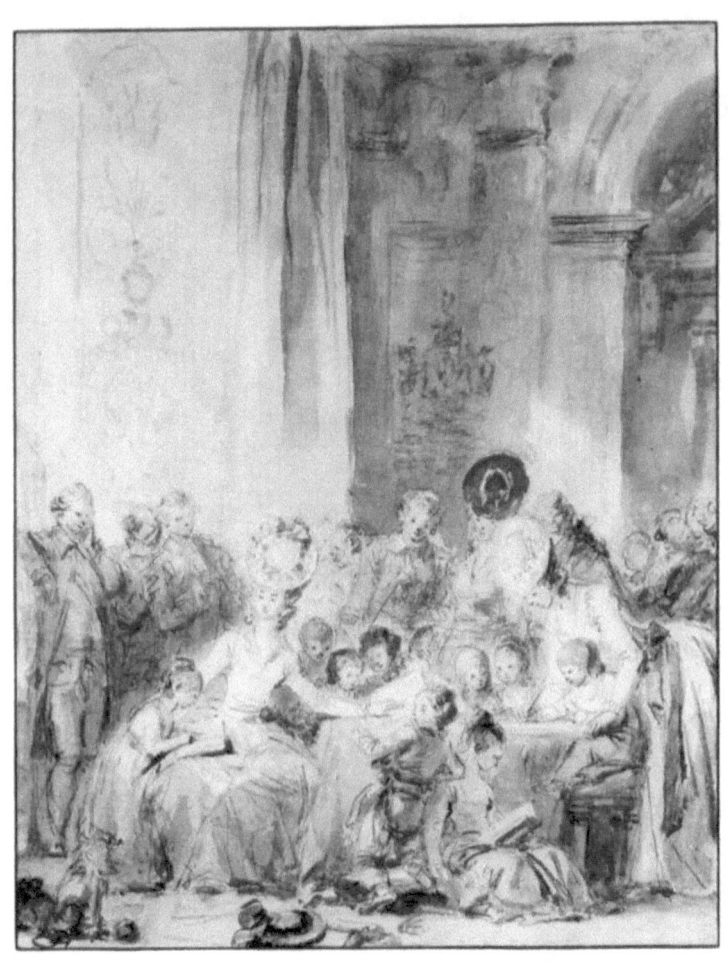

Competition or instruction in reading, 1780–1790, ink drawing on chalk

At the stove, Oil on canvas

Francois the I-st in the studio of Rosso, Oil on canvas

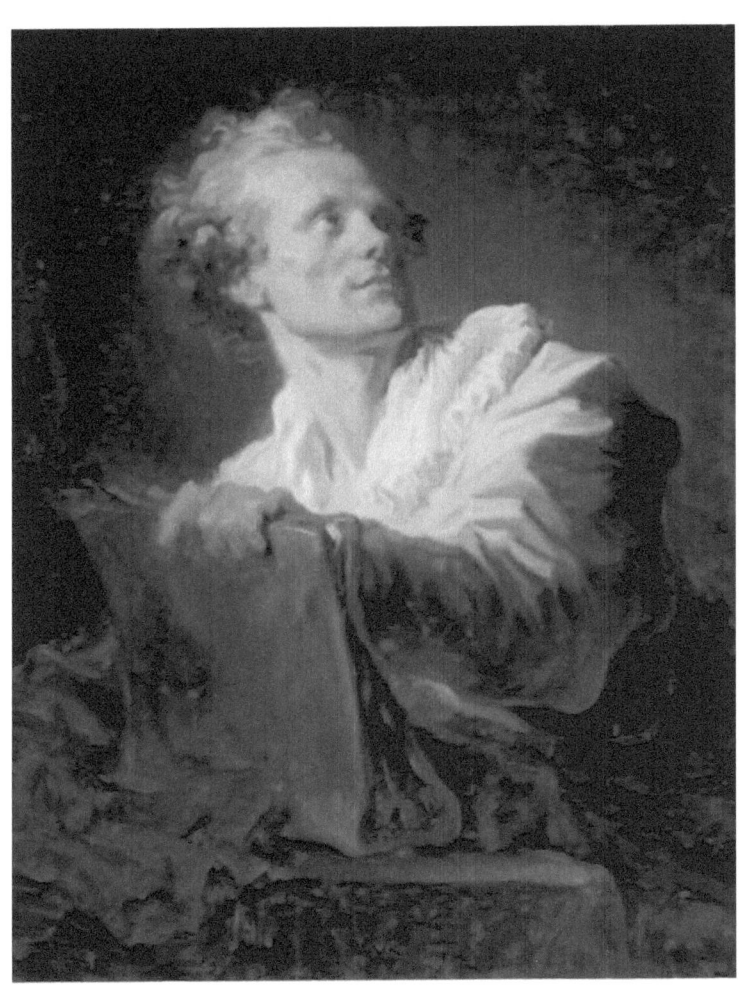

Portrait of a Young Artist, presumed to be Jacques Andre Naigeon, Oil on canvas

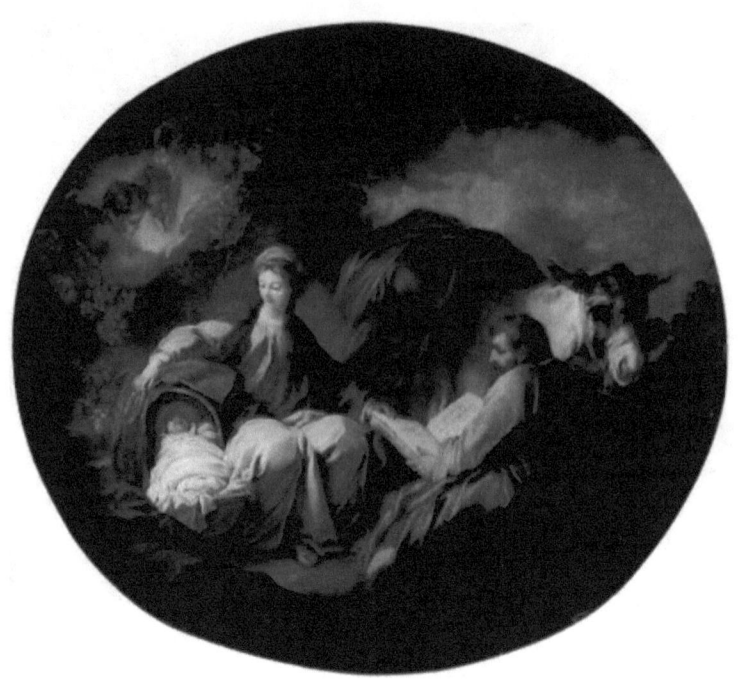

Rest on the Flight into Egypt, Oil on canvas

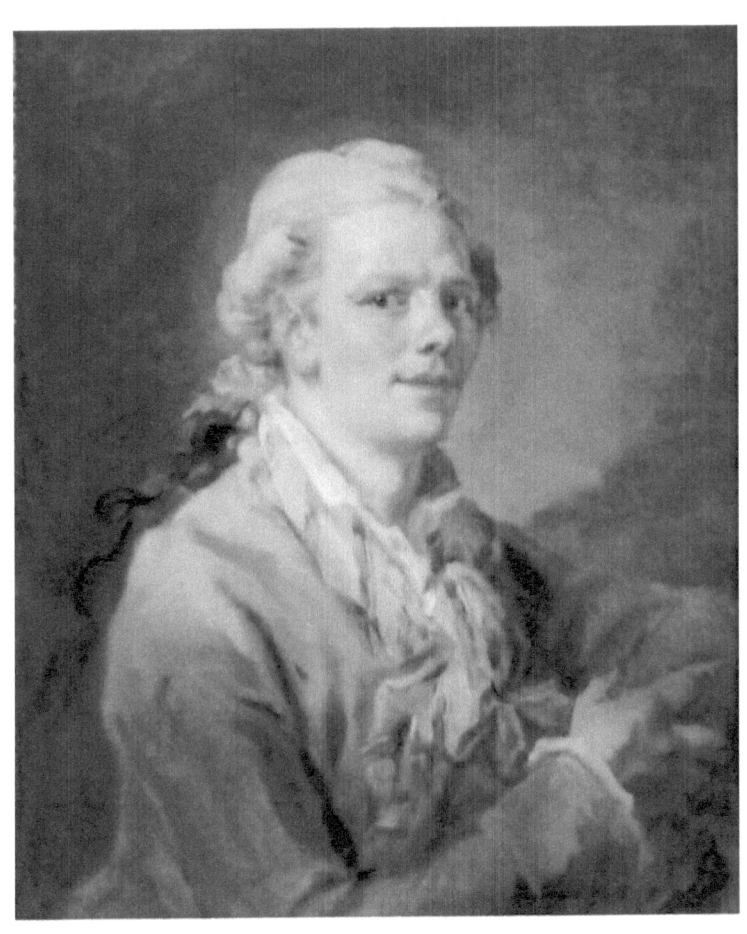

Self-portrait, Oil on canvas

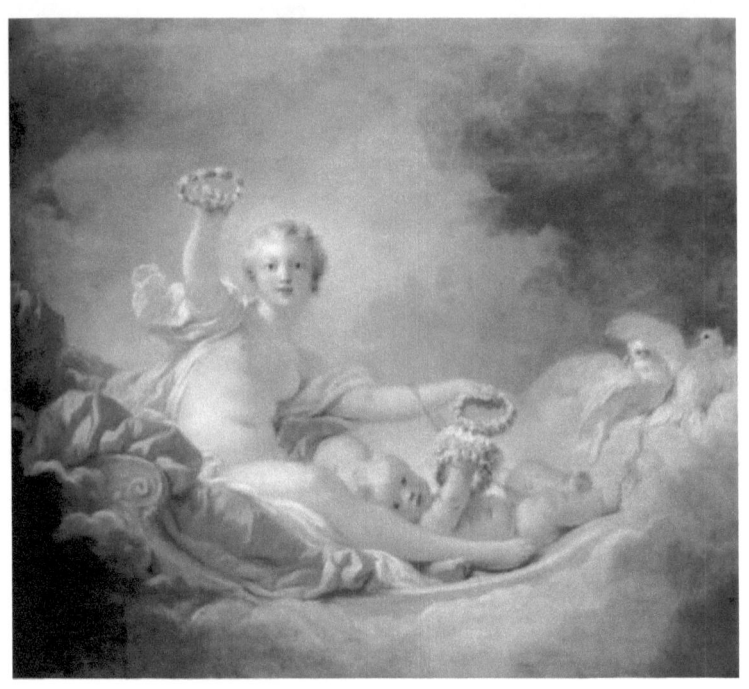

Venus and Cupid (The Day), Oil on canvas

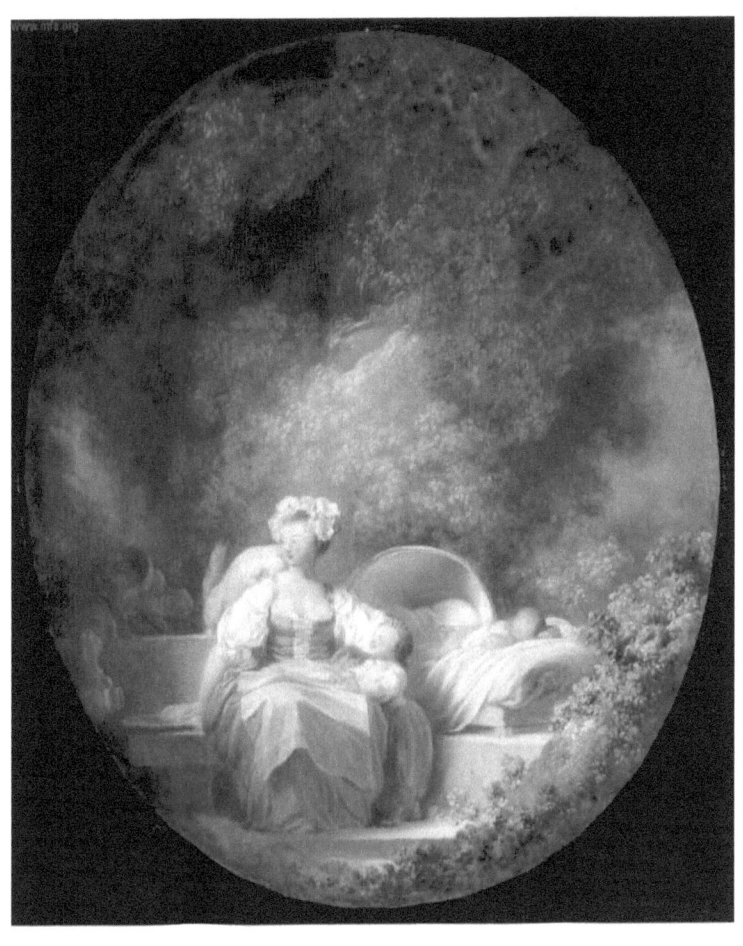

The Good Mother, Oil on canvas

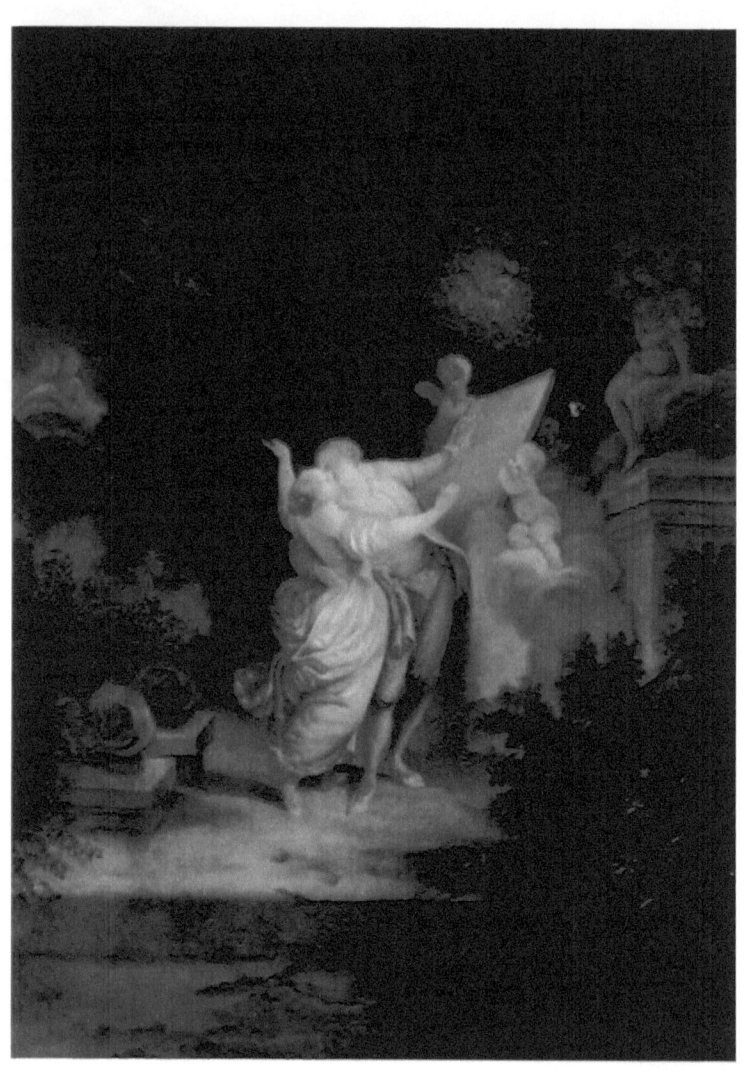

The Sermon of Love, Oil on canvas

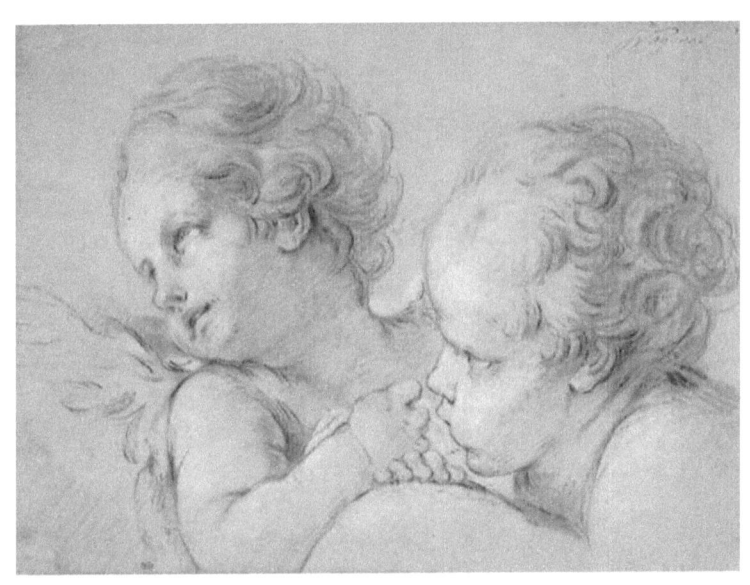

Two heads, drawing

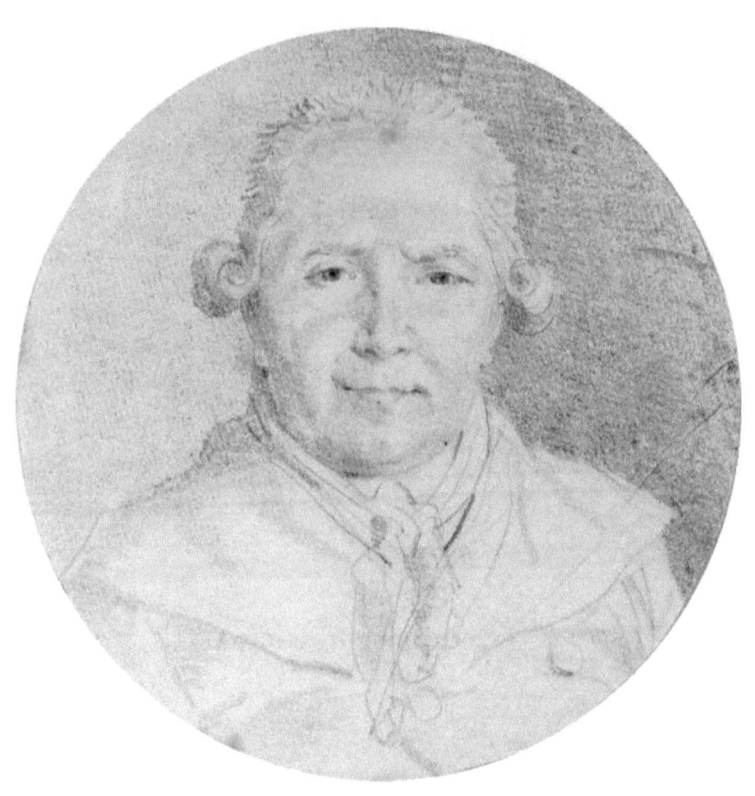

Self-portrait, Drawing

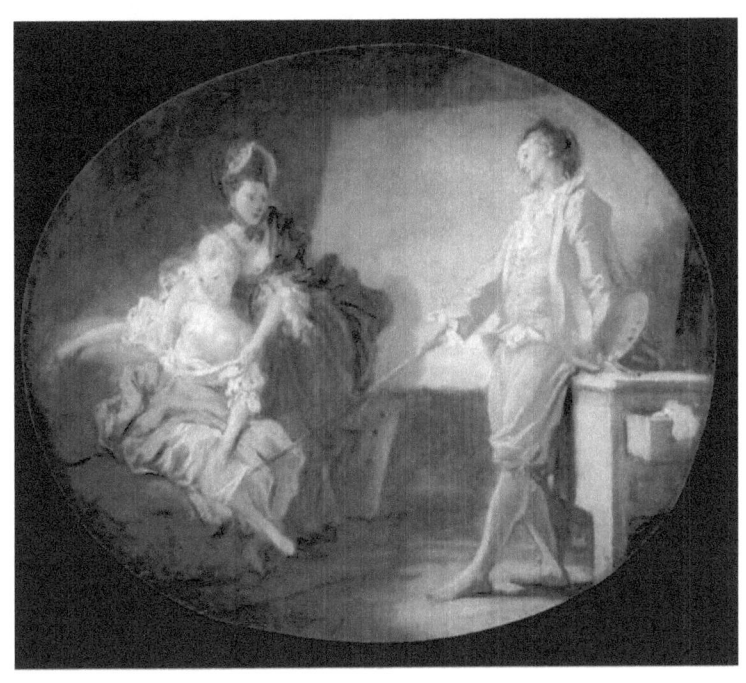

The beginnings of model, Oil on canvas

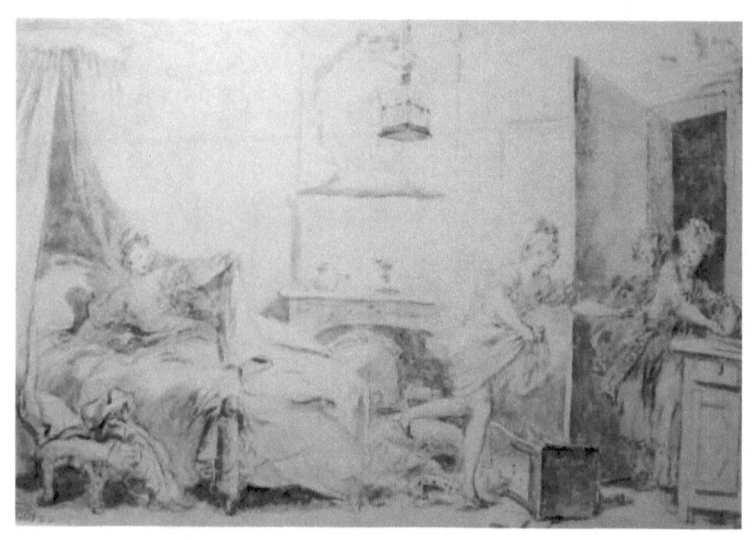

Burn my shirt, Drawing

Pasha, drawing

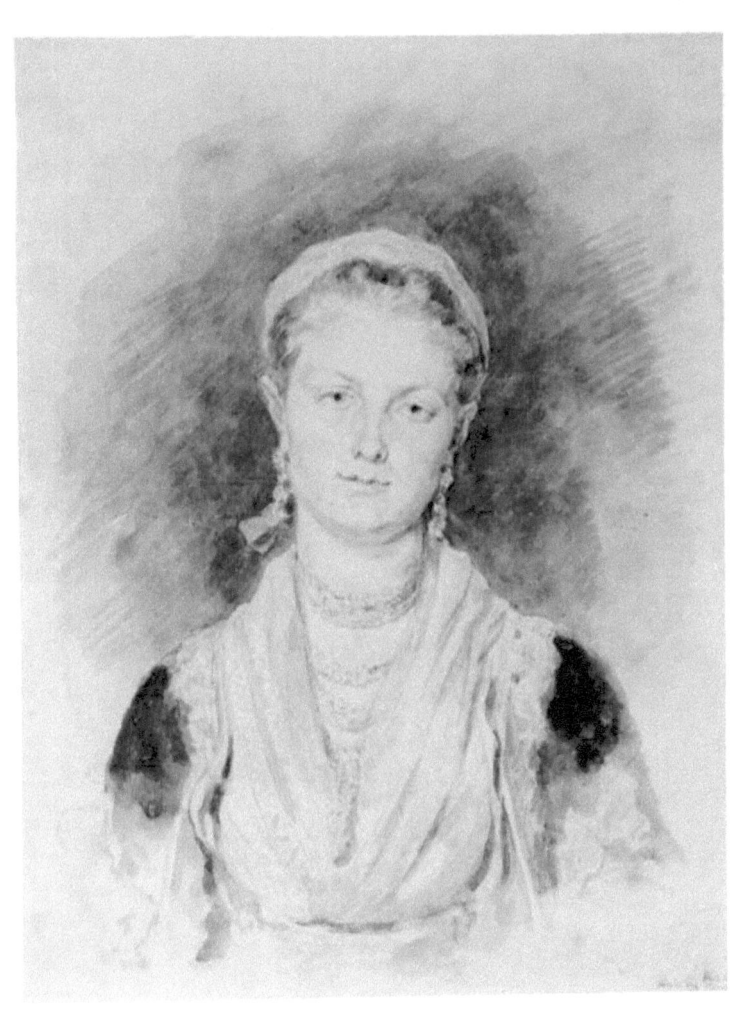

Neapolitan girl, drawing

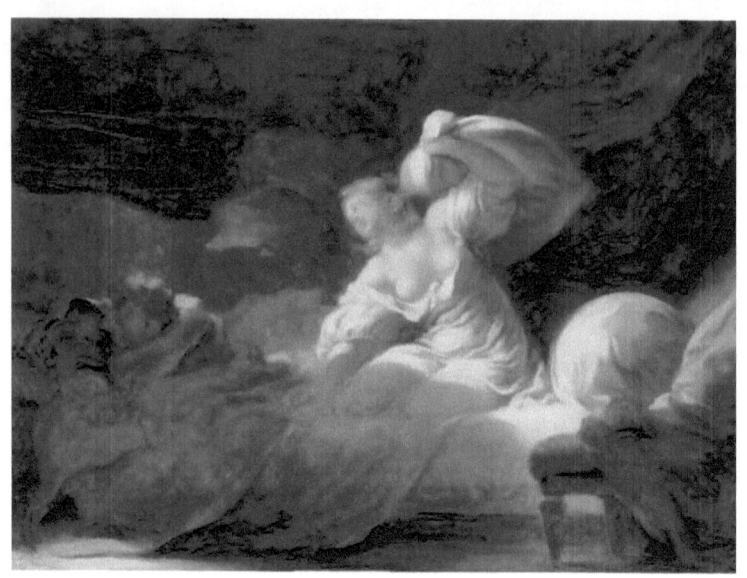

The fight unnecessary, Oil on canvas

www.ingramcontent.com/pod-product-compliance
Lightning Source LLC
Chambersburg PA
CBHW030841180526
45163CB00004B/1414